IMAGES
of America

THE SCARAB CLUB

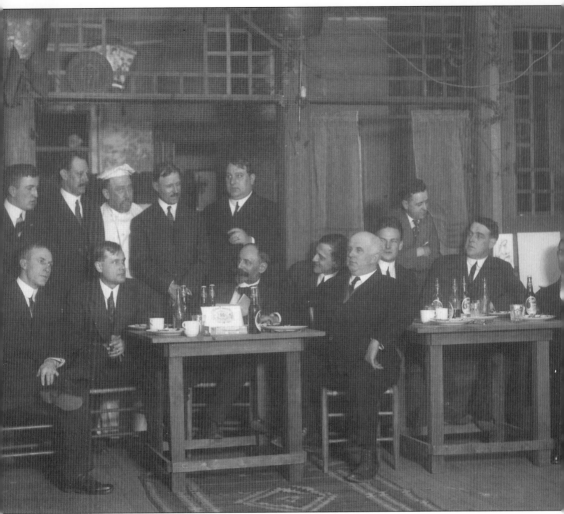

Right from the start, sustenance and libations were a regular ritual wherever Scarab artists and patrons met. Members rotated the duties of menu planner, chef, and server. Scarab president James Swan, pictured in the chef's hat, was well admired for his delicacies as well as his leadership. This 1912 photograph by Frank Scott Clark depicts members and guests at play, enjoying the camaraderie as much as the food and drink, at their Gratiot Avenue location.

On the cover: Please see above. (Courtesy of the Scarab Club Archives.)

IMAGES
of America

THE SCARAB CLUB

Christine Renner, Patricia Reed,
and Michael E. Crane

ARCADIA
PUBLISHING

Published by Arcadia Publishing
Charleston SC, Chicago IL, Portsmouth NH, San Francisco CA

Printed in the United States of America

Library of Congress Catalog Card Number: 2006928116

For all general information contact Arcadia Publishing at:
Telephone 843-853-2070
Fax 843-853-0044
E-mail sales@arcadiapublishing.com
For customer service and orders:
Toll-Free 1-888-313-2665

Visit us on the Internet at www.arcadiapublishing.com

The scarab, an Egyptian symbol of rebirth, represents the club's commitment to the perpetual renewal of the arts. In accordance, this publication is dedicated to the memory of Scarabs' past, in honor of Scarabs' present, for inspiration of Scarabs' future, and as a tribute to all art enthusiasts. The authors are appreciative for the memoirs of Scarab members who tread before us and, upon their journey, gifted a wealth of historical artifacts and a clubhouse for the artistic inspiration of future generations.

CONTENTS

ACKNOWLEDGMENTS

Scarab members past, present, and future provide the inspiration for this pictorial essay representing the last century of the organization's history. Most importantly, a special thanks is in order for the 2005–2006 Scarab Club Board of Directors who approved the book's creation and believed in the authors' dedication to accurately portray the club's history through its archival treasures. The board of directors includes Pres. Patricia Reed, Vice Pres. James W. Tottis, secretary Lynn Jovick, treasurer Marisa Lenhard, and directors Joseph Ajlouny, George R. Booth Jr., Nadine Deleury, Ralph Hartshorn, Nina Maggart, Joseph M. Neumann, William Murcko, Ellen Tallant, and John Wickey. For many hours of absence of the authors' companionship, family members are acknowledged for their patience during the research, compilation, and composition of this publication: Michelle Yovanovich-Crane, Randell Reed, and Matt and Logan Renner (a Detroit Tigers fan). Proofreading was the product of a partnership between James W. Tottis and Timothy M. Burns, American Art department of the Detroit Institute of Arts (DIA). The DIA continues as a source of inspiration for providing documentation missing from Scarab Club archives and participating in historic partnerships. Additional individuals are recognized for providing insightful information: Tom Yanyl, who provided the contacts for Frank Scott Clark's family: Betty LaFrey, granddaughter, and Jennifer Bade, great-great granddaughter, who were a delight to interview; Steven Boichot, grandnephew of Joseph W. Gies, who donated a collection of Gies's artwork and historic photographs to the Scarab Club; Scarab past president George R Booth Jr., who pictorially documented much of the club's past 40 years and donated his photographs to the club's archives; Dr. Jerald A. Mitchell, previous Scarab Club archivist, who understood the need to organize and safeguard archival files and artifacts for the ease of future research; William and Mary Jane Bostick, who shared their oratorical history; Howard Aston, son of charter woman member Mariam S. Aston; Ken Randall for providing information on Paul Honore; and countless others who have put forth great effort to donate or maintain the precious historical material.

INTRODUCTION

What mystery and intrigue does a strong, vertical brick edifice with two heavy wooden entry doors, and elevated windows surrounded by the large facades of its sister art museum, a modern historical museum, contemporary science center, and an art college hold for those who happen by and are brave enough to venture inside? The foreboding doors speak of a private past that still intimidates the meek in the 21st century. What is this place, this historic building trapped in its more modern surroundings? Glide through historic portals into a building on the local, state, and national historic registers, founded, designed, built, and decorated by its artist and patron members.

The Scarab Club still proudly maintains its roots in the city of Detroit. Since its founding in 1907, the Scarab Club continues to be one of the great treasures rooted in the city's cultural, artistic, and historic community. After opening its doors at its current location in 1928, the club still offers vital services in the visual, fine, and performing arts for its members and the metropolitan Detroit area. Originally named the Hopkin Club after maritime and landscape painter Robert Hopkin (1832–1909), its members consisted of local artists and patrons who desired to share their mutual inspiration for the arts. Discussions, sketch sessions, food, and libations made their informal meetings a delight. In 1910, the name was changed to the Scarab Club following Hopkin's death.

During the early 20th century, there was a yearning for artists and art enthusiasts to gather on a less formal basis. Detroit, like many other major cities in America, had a formal artistic and cultural history predating the Scarab Club. Among the various art schools available was the Detroit Art Association (1875), the Art School of the Detroit Museum of Art, which was founded shortly after the museum's opening in 1885, and the Detroit Fine Arts Academy (1895–1911) founded by Joseph W. Gies (1860–1935) and Francis Petrus Paulus (1862–1933). Upon Gies's retirement, the academy was purchased by John P. Wicker (1860–1931) and became the Wicker School of Fine Arts. Additional instruction was available through the Detroit Society of Arts and Crafts, especially upon the formulation of the school of Arts and Crafts (1926), and under the private tutelage of prominent local artists.

The impetus of the Scarab Club provided structure for like-minded artists and art admirers to meet and share ideas. Communal gatherings of people with the same interests provided a creative environment where ideas could be freely entertained.

At the same time as early members were drawn together by this motivation, other clubs and organizations were beginning to form such as Pewabic Pottery (1903), Detroit Society of Women Painters (1906), and the Players Club (1911). All shared the spirit of creativity and art appreciation.

This desire to form arts organizations in Detroit during the first third of the 20th century was partially intertwined with the birth of automotive design and the evolution of advertising art inspired by the burgeoning automobile industry. Founded in 1907, the Ford Motor Company introduced the innovative assembly line in 1907 that influenced a mass migration to the city. At this time, Detroit became one of the fastest-growing cities in America, with population growth corresponding with automobile manufacturing and sales. Compared to Detroit's early population of 45,000 in 1860, there was a significant population boom by 1920 when resident numbers reached approximately 1 million.

Detroit's population explosion due to the growing automobile industry inspired the nicknames "Motown" and the "Motor City," which the city is still called today. Although generally viewed as a heavily industrial city, Detroit's artistic community thrived from the success of the automobile. Soon automotive design and advertising illustration became well-respected fields. Art schools soon began to conduct classes on these subjects, which led to a friendly relationship between automotive companies, teachers, and students.

Many of the original founding members of the Scarab Club consisted of automotive designers, advertising illustrators, graphic artists, photographers, architects, and automobile company owners. Members included automotive pioneers Charles and Lawrence Fisher of the Fisher Body Corporation (division of General Motors) and Edsel Ford (Ford Motor Company). Hopkin Club founding member George Hodges (1864–1953) made the first enclosed body for a Ford automobile and claims to have developed the first powered lawn mower.

Scarab Club members inspired each other's artistic spirit by displaying their artwork in the Annual Exhibition of Michigan Artists and invitational, juried, and members' gallery exhibitions. Among the member and non-member artists, distinguished guests were invited to sign the "guest book" on the beams in the second-floor lounge at the club's permanent clubhouse at 217 Farnsworth Street.

Besides hosting various events, such as the costumed Scarab Club balls, for members and to attract new membership and patronage, the Scarab Club managed working artist studios, which still continue today. Since its founding in 1907, the Scarab Club continues to be a driving force in the artistic community and is proud to serve Detroit as a cultural stimulant for greater artistic diversity in the 21st century.

Much like many clubs with informal roots, the early history is skewed with multiple well-intended accounts. For accuracy, the authors have relied greatly on the original accounts given by founding member Clyde H. Burroughs (1882–1973) in the 1928 *Scarab Club Bulletin*. Burroughs, among other things, was a leading administrator at the Detroit Institute of Arts (DIA) who served as secretary, twice as director, and as the first curator of American art. The thematic focus of the book highlights early organizational history; various clubhouse locations and architectural development, design, and use of the current clubhouse; prominent artist and patron members; exhibitions including the Annual Exhibition of Michigan Artists, invitational, juried, and members'; famous signatures on the beams in the second-floor lounge, including visual, literary, and performing artists, politicians, and past presidents; information on the infamous, costumed Scarab Club Balls as well as other significant events; past and present working artist studio tenants; and the diversity of 21st-century cultural events that stimulate local art, including partnerships with other local organizations.

One

ORGANIZATIONAL
HISTORY

What was the motive and consequential future of a group of artists and art patrons meeting after lectures in the trustee's room of the Detroit Museum of Art around 1907? The inspiration to gather was founded on their mutual interest in art and to stimulate the local art focus. This informal group later called themselves the Hopkin Club in honor of Robert Hopkin, the "granddaddy" of Detroit artists. After Hopkin's death in 1909, members searched for a new, notable name. The Scarab Club was the unanimous decision, inspired by Pres. James Swan's collection of carved Egyptian scarabs. In 1913, the club formalized with the adoption of bylaws and a board of elected officers and directors. Activities still include sketch sessions, art discussions and lectures, social events, art exhibitions, and related activities to showcase art and educate the community in the arts. During the early years, several clubhouse locations provided meeting space. Finally, in 1928, members settled into the current building, which accommodated a variety of artist members including visual artists, sculptors, musicians, illustrators, writers, and architects.

In the beginning, it was exclusively a men's organization initially limited to 25 members. During the same period, women artists participated in the Detroit Society of Women Painters and Sculptors, a female counterpart. As clubhouse space became more accommodating, the Scarab Club membership levels increased. In 1962, the Scarab Club Board of Directors, led by Pres. William A. Bostick, who was encouraged by his wife, Mary Jane, voted to open the membership to women. Bostick called women "the saviors of the club!" Even though both sexes were engaged, membership faltered to about 125 during the 1970s recession. The drive and ambition of the artist and patron members since then has helped to increase the membership to more than 270.

Membership categories varied throughout Scarab history. In the beginning there were three levels: active artist (primary employment was in the arts), associate artist (an art hobbyist), and lay member (art connoisseur). Today membership levels vary and include both artists and patrons, each with a graduated scale of benefits.

Robert Hopkin (1832–1909), born in Glasgow, Scotland, who emigrated to Detroit with his family in 1843, was a predominately self-taught artist and celebrated marine and landscape painter who also produced theatrical backdrops and executed ornamental interior decorating for churches and businesses. Hopkin exhibited in many local and national art exhibits including Pennsylvania, New York, and Illinois, and belonged to several Detroit art societies as well as the Art Institute of Chicago and the Society of Western Artists. Detroit artists and patrons were revered and inspired by Hopkin and rallied around him after lectures in the trustee's room at the Detroit Museum of Art (DMA). As a result, they began meeting informally at the DMA and in his studio to discuss and practice art. About 1907, they began calling themselves the Hopkin Club in his honor. Pictured is Hopkin's portrait painted in 1907 by Joseph W. Gies, a Hopkin Club founding member, in the collection of the Detroit Historical Museum. (Courtesy of the Detroit Historical Museum, photograph copyright 1930 by the Detroit Institute of Arts.)

The scarab was chosen as the symbol of the club after Robert Hopkin's death in 1909. James Swan (1864–1940), Scarab president (1910–1913), attorney, artist, and art patron, had a collection of gemstones and semiprecious stones; among them were carved Egyptian scarabs that represent resurrection of life. While looking through his collection, members were inspired by the idea to rename the organization the Scarab Club. (Courtesy of the Scarab Club Archives.)

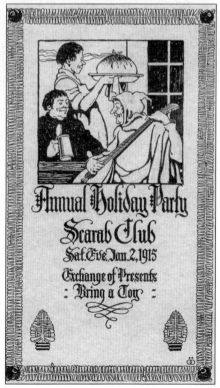

The Scarab annual holiday party was an event that members looked forward to. This 1915 postcard portrays the party's merriment, announces the exchange of presents, and asks members to "bring a toy." Members were responsible for preparing and serving the food as well as playing the piano and singing for their own entertainment. (Courtesy of the Scarab Club Archives.)

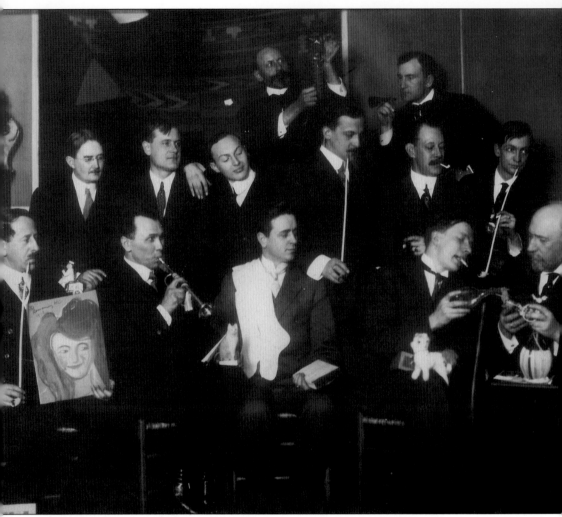

Scarabs, depicted in this photograph by Frank Scott Clark, enjoy the "silly toy" exchange at their 1912 Christmas party held at the Gratiot Avenue clubhouse. Pictured in the front row are, from left to right, George A. True (1863–1925), an industrialist and artist; Charles E. Waltensperger (1871–1931), an artist; Clyde Burroughs (1882–1973); Carl Bender, an artist; and James Swan (1864–1940), an attorney and artist. Pictured in the second row are, from left to right, David Heineman (1865–1935), a lawyer, politician, publicist, and designer of the official flag of the city of Detroit in 1908; Horace S. Boutell (born in 1879), a paint company manager; Henry Kruger Jr., an artist; Roman Kryzanowski, an artist; Albert Edward Peters (1865–1939), a business executive and artist; and Roy Marshall, a patron. Pictured in the third row are, from left to right, Joseph W. Gies (1860–1935), the founder of the Detroit Fine Arts Academy, which existed from 1895 to 1911; and Ivan Swift (1873–1945), an artist and poet. (Courtesy of the Scarab Club Archives.)

In 1913, the *Scarab*, a proposed weekly magazine, became a historic memento of members' humorous and serious artistic illustrations of early events of social, economic, and political expression. In the October 1914 issue, Charles Culver indicated that "care should be exercised in giving the public press material from the magazine . . . much of its contents was too personal to be given publicity outside the club." (Courtesy of the Scarab Club Archives.)

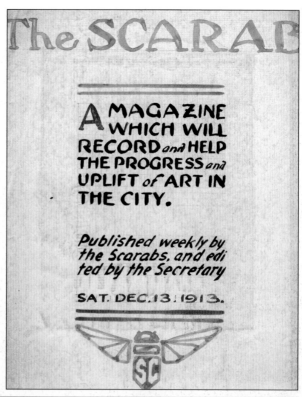

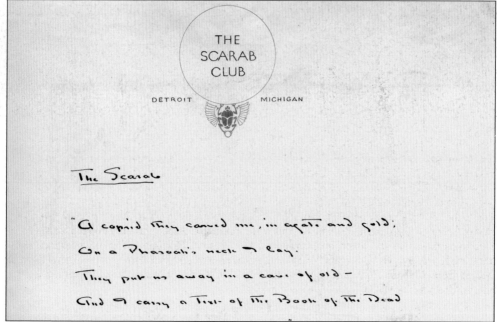

"The Scarab," a poem by Ivan Swift written on newly proposed letterhead, was published in the *Scarab* October 1914 issue. "A coprid they carved me in agate and gold; on a Pharoah's neck I lay. They put us away in a cave of old, and I carry a text of the Book of the Dead as I roll my ball of clay." (Courtesy of the Scarab Club Archives.)

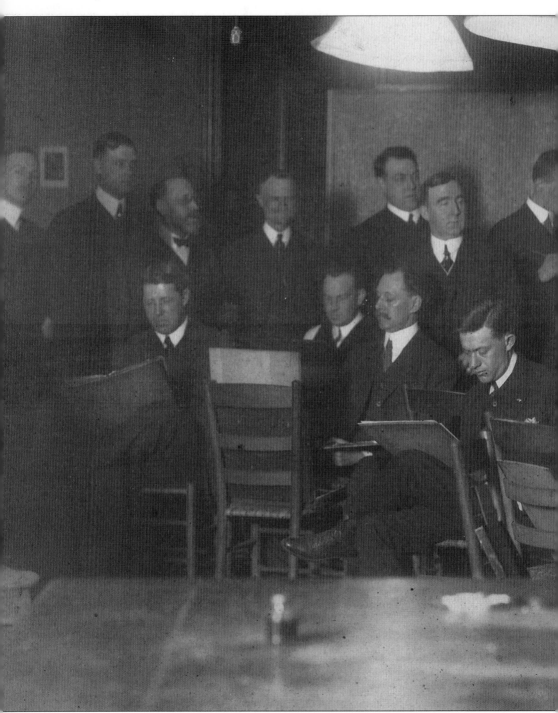

At the beginning of World War I in 1914, this sketch class photograph by Frank Scott Clark was captured at the second clubhouse on Witherall Street. Scarabs are engaged in the seriousness of their craft. Standing are, from left to right, Henry Kruger, Horace Boutell, Alfred Nygard, William Weber, Charles Culver, Harry Woodhouse, Roman Kryzanowski, Clyde Burroughs, Joseph Gies,

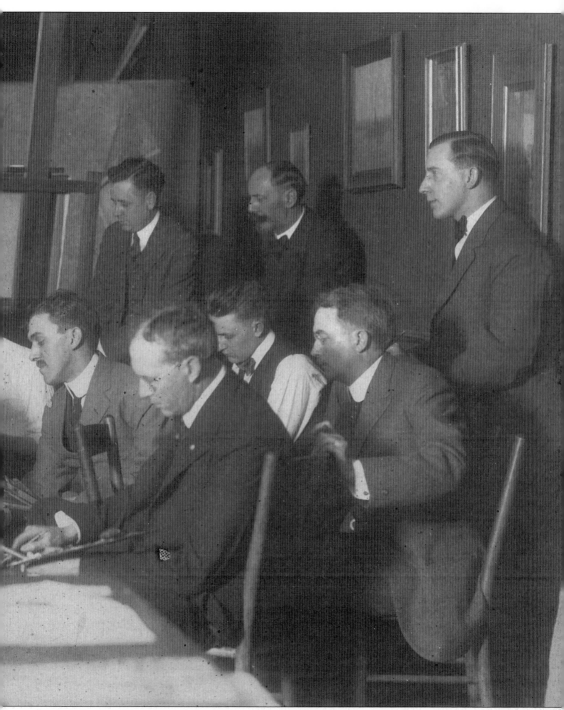

and unknown. Seated are, from left to right, Charles King, Roy Gamble, Albert E. Peters, Russell Legge, Harry Smith, Arthur Jaeger, John A. Morse, unknown, and George True. Sketch sessions remain a revered event at the club in the 21st century. A copy of this photograph was placed in the cornerstone of the current clubhouse. (Courtesy of the Scarab Club Archives.)

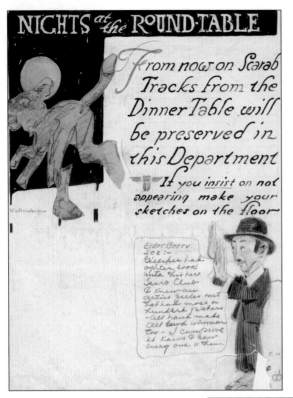

The *Scarab* magazine started a new chapter titled "Nights of the Roundtable." Brown butcher paper was ceremoniously rolled out on the dining table in the club room. Artists were encouraged to sketch as they socialized during luncheons or evening-hour events. These sketches were cut out and placed in the magazine as a tribute to the camaraderie. (Courtesy of the Scarab Club Archives.)

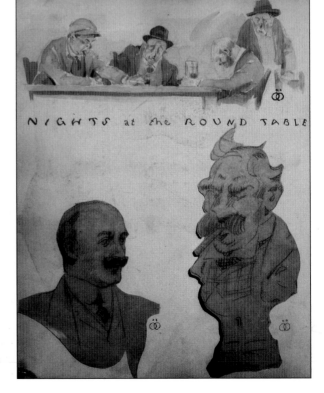

This is a sampling from the April 1914 *Scarab* magazine of the sketches created by members at a recent evening's event. It shows a watercolor sketch of weary members after their carousing and two cutouts of character sketches. The images were created by Russell Legge who used a symbol of two interlocking circles with two dots above to represent his signature. (Courtesy of the Scarab Club Archives.)

To meet its mission, the Scarab Club invited speakers on art topics. Sadakichi Hartmann (1867–1944), art critic and lecturer, was invited to conduct a course of lectures as indicated in the October 3, 1914, meeting minutes. This sketch was rendered by Burt Thomas, member and political cartoonist for the *Detroit News* from 1912 to 1951, and appeared in the 1914 New Quarters issue of the *Scarab*. (Courtesy of the Scarab Club Archives.)

THE SCARAB CLUB
invites you to attend the following course of lectures
by
SADAKICHI HARTMANN
to be given in the auditorium of the Detroit Museum of Art

Wed. Oct. 21ᵗʰ 8 O'clock
White Chrysanthemums
A Discussion of Japanese Art

Sun. Oct. 25ᵗʰ 3 O'clock
Tomahawk and Indian Corn
A Plea for American Art

Wed. Oct. 28ᵗʰ 8 O'clock
Pigments and Cubes
What the Public should know about Technique

This invitation from the October 1914 *Scarab* shows topics for Sadakichi Hartmann's lectures. The October 17 meeting minutes state "It was decided to hold three lectures under our auspices at the Club rooms by Mr. Hartmann at a minimum price of $25 per lecture." The lecture was cancelled due to lack of interest, according to the October 21 minutes, but Hartmann was still paid his sum of $75. (Courtesy of the Scarab Club Archives.)

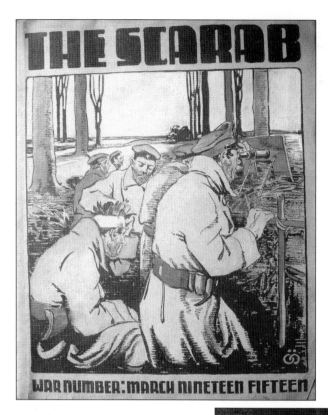

The *Scarab*, "War Number," March 1915, is a sample of many magazine covers decorated by members. Although it was an honor to have one's art chosen for the cover, it was also an effort to secure the artists' contribution. Although few images inside this publication relate to war, the club showed its commitment to aiding the war effort through an art exhibition. (Courtesy of the Scarab Club Archives.)

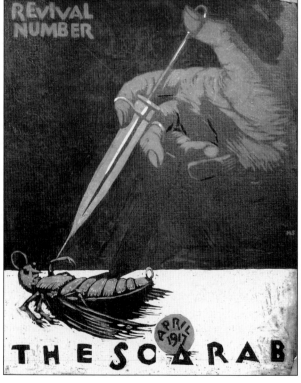

This cover is from the 1917 "Revival Number" of the *Scarab*. As with any organization, the club experienced its ups and downs. This was one of the last issues produced, encouraging members to take action and supply artwork and ideas in order for the publication to continue. (Courtesy of the Scarab Club Archives.)

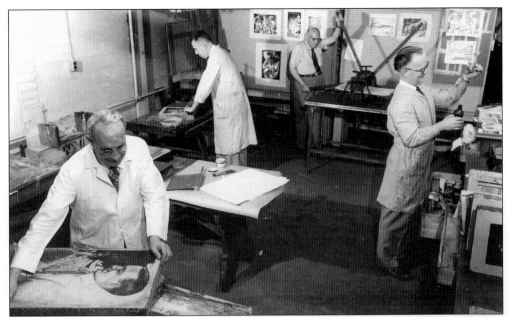

In 1953, the board of directors produced a marketing publication for the club. This featured photograph by Ransier Studio depicts the lithographing room as "one of the busiest places . . . in which lithographing and etching machines are maintained. No charge is made for this service which is available at all times to Scarab Club members." (Courtesy of the Scarab Club Archives.)

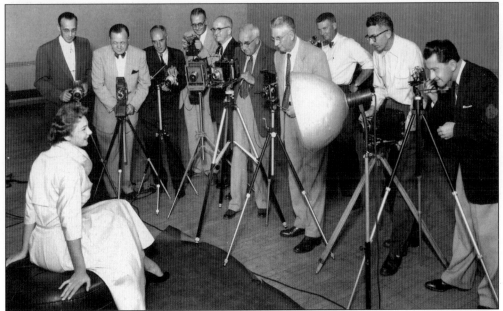

"One of the most important attractions of the Club is the Photographic Club . . . [which] has its own program . . . the many problems and developments in this field are presented and eagerly discussed . . . All members of the Scarab Club who are interested in the photographic arts are welcome to join this group." This photograph by Ransier Studio is featured in the 1953 marketing publication. (Courtesy of the Scarab Club Archives.)

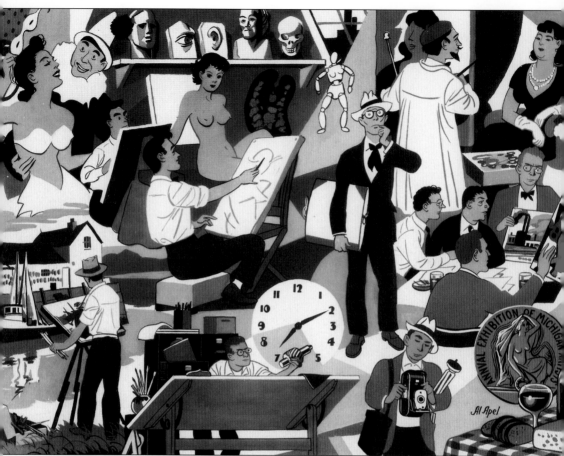

Al Apel's illustration featured in the 1953 marketing publication *The Founding and Growth of the Scarab Club of Detroit* depicts costumed balls, enjoyment of food and wine, the Annual Exhibition of Michigan Artist's gold medal, painting, sculpting, architecture, photography, life drawing, clothed models, and jurors making exhibition selections. Although many tried to capture this type of image, Apel's was exceptional. The publication states in the chapter adjacent to the image titled *The History of the Scarab Club*, "The Scarab Club as it stands today is testimony to the untiring and generous efforts of a small group in the earlier history of this organization and of the newer members who have lent their time and thought to the establishment of a vital force for greater art knowledge and appreciation in the community. Reminiscences of the activities and accomplishments of these earlier members may serve to chart a clearer, more direct course to still greater and more significant achievement." (Courtesy of the Scarab Club Archives.)

Two

CLUBHOUSE LOCATIONS

Where do scarabs dwell and buzz? During the Hopkin Club years (1907–1910), members met in various locations, the first being the Detroit Museum of Art at the corner of Jefferson Avenue and Hastings Street. Following art lectures, members would gather for Bohemian-style evenings in the trustee's room. Robert Hopkin's (1832–1909) relatives indicated to the current Scarab Club archivist that his Detroit residence and studio provided an additional meeting place for art discourse.

Gatherings were so successful that a decision was made in 1911 to lease the third-floor loft at 80 Gratiot Avenue at Randolph and Brush Streets, next door to a tobacco warehouse, which emitted an aroma that enhanced the artistic atmosphere. The first member to enter the quarters was expected to fuel the railroad stove, missing one leg and propped up on two bricks for support.

As membership grew, new quarters were leased in May 1914 on the second floor above Herman Bowman's saloon at 10–12 Witherell Street on the corner of Broadway Street. The smell of beer and cigar smoke contributed to the ambience in the new clubhouse and provided an additional place for members to seek food and refreshments after finishing their upper-level evening activities. As this location was slated for demolition, Scarabs moved again in January 1917 to temporary quarters at the Addison Hotel on Woodward Avenue between Charlotte and Petersboro Streets. From midsummer 1917 until November 1, 1922, members used the third floor of the Studio Building on 2036 Woodward Avenue at the corner of Elizabeth Street, which was owned by member Frederick Zeigen. In 1922, the membership and treasury grew and a clubhouse was purchased at 253 East Forest Avenue between John R and Brush Streets. Soon dreams of building a clubhouse for their specific purpose with exhibition space, studios, a members' lounge, and classroom space became a reality. In 1926, a group of 15 member architects selected the new building's architect, Lancelot Sukert (1888–1966). In 1928, the final and current clubhouse was built at 217 Farnsworth Street. The design, building construction, and architectural and decorative elements were all executed by the membership.

Members eagerly anticipated the move to the second floor at 10–12 Witherall Street across from Grand Circus Park. Charles B. King sketched his sentiment and used a play on words to represent the May 1 move for the 1914 *Scarab* magazine. In jest, he portrayed the park as a circus with a trainer taming a bear and a lion at rest. (Courtesy of the Scarab Club Archives.)

Russell Legge sketched Herman Bowman for the 1914 *Scarab* magazine. Bowman, the landlord and proprietor of a first-floor saloon in the Witherall Street building, was born in Pennsylvania of German descent according to the 1910 U.S. Census. However, he is depicted with a boastful chest, plaid tie, and horseshoe indicative of another nationality in the sketch. Scarabs used the second floor of his building for their clubhouse. (Courtesy of the Scarab Club Archives.)

This October 1925 sketch portrays the rear of the clubhouse at 253 East Forest Avenue purchased in 1922. Floyd S. Nixon created the woodblock print for the cover of this issue of the *Scarab* magazine. Each month, artist members were encouraged to submit artwork for the magazine. (Courtesy of the Scarab Club Archives.)

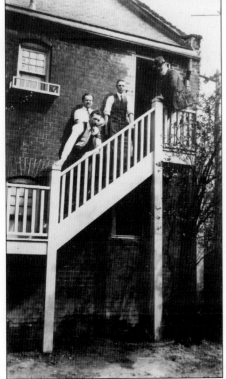

The East Forest Avenue clubhouse was purchased and occupied by the Scarabs from 1922 to 1928 then leased to another organization until its sale in the 1930s. This 1925 photograph depicts the rear entrance with the first four studio tenants who occupied the renovated rear building. Pictured in front are, from left to right, Reginald Bennett and Joseph Gies, and in back are Paul Honore and Sidney Walton. (Courtesy of the Scarab Club Archives.)

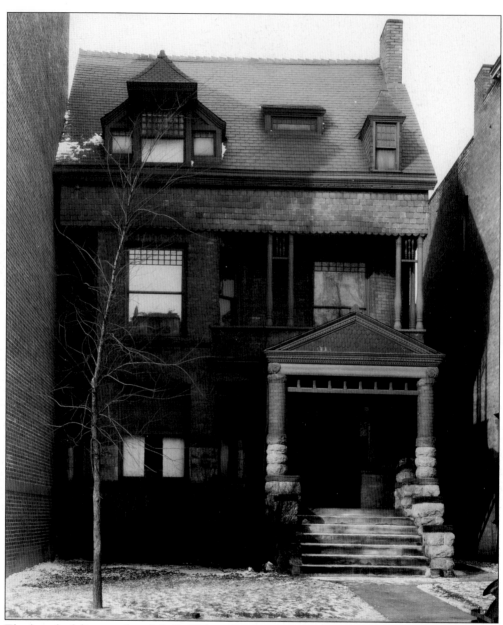

The board of directors hired A. R. Wilson Studios to capture the image of its 253 East Forest Avenue clubhouse on January 21, 1928, the only photograph in the Scarab Club archives of the building's facade. It is interesting to note that a painter's palette was the backdrop for the street number. The first mention of a search for a new home was in the board meeting minutes of September 28, 1921. At the board meeting of October 5, 1922, it was resolved to purchase this property for $21,000, and pay $5,000 down at 6 percent annual interest using the new $500 life membership income toward the property. Board meeting minutes of September 24, 1924, suggest, "To consider the advisibility [sic] of making four studios out of the brick building in the rear of the . . . club for rental to artist members." Eventually the space was converted and studios rented. Even after the 1928 construction of the existing clubhouse, the studios remained rented by members until the 1930s sale of this location. (Courtesy of the Scarab Club Archives.)

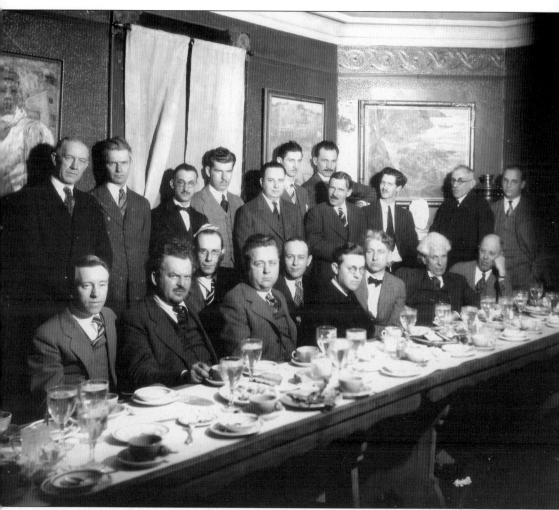

The February 1928 *Scarab Club Bulletin* states, "A recent photograph, taken in the present clubhouse at a noonday luncheon . . . not only [represents] members of the Club, but also the death mask of Willy Sesser." This interior photograph of the East Forest Avenue clubhouse shows members from that time period and the Walter Piper Prize–winning paintings secured for the permanent collection in the background. Willy G. Sesser's (1886–1927) death mask is located below the seascape painting by George Styles at the far right. The January 1928 *Scarab Club Bulletin* states, "Under his leadership, the plan for a new clubhouse was started . . . a few days after the first ground had been turned on the site for the new club, . . . Sesser's heart refused to carry further the burden of his responsibilities." A. R. Wilson Studios was responsible for the photograph, which was deposited in the new building's cornerstone. (Courtesy of the Scarab Club Archives.)

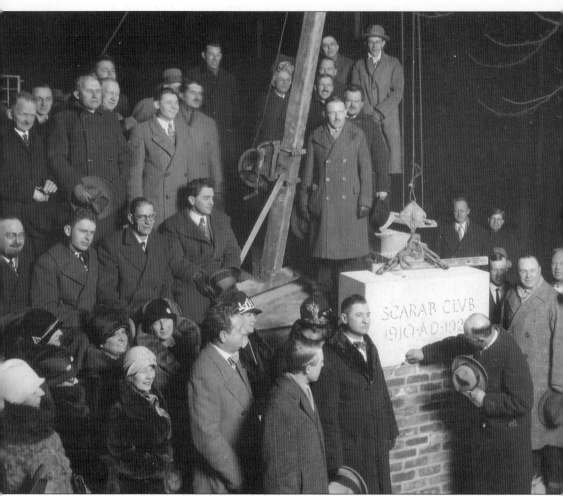

The cornerstone laying of January 21, 1928, was captured by A. R. Wilson Studios. Pres. Stanley Lewis checks the exactness of the stone setter while architect Lancelot Sukert stands to his right with hat in hand. The February 1928 *Scarab Club Bulletin* states, "When time and the tide of fortune dictate the demolition of the new Scarab Club, whether to make way for an even more pretentious home or to surrender its site to other uses, the leaden box [placed inside] . . . will doubtless be opened." Contents include photographs of club activities, a membership list, copies of the *Scarab*, Michigan Artists Exhibition Catalogs from 1911 to 1928, Scarab Ball invitations from 1917 to 1928, a check for $100 made out to the club whose signer "declared he'd live in fear the building would blow down," and a poem by Gordon Damon, "Judge us not by things you've done, by the laurels you have won; let the standards of the past be your measure when at last the trifles in this box concealed to your vision are revealed." (Courtesy of the Scarab Club Archives.)

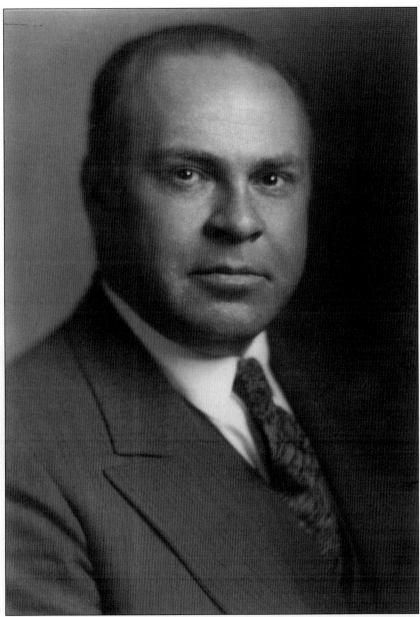

Lancelot Sukert (1888–1966) was chosen by architect members of the club to design the new clubhouse. Frank Scott Clark captured him in this photograph taken in 1928, donated to the club by Sukert's widow in 1978. Sukert, a 1907 graduate of Detroit Public Schools, studied architecture at the University of California, Architectural School of Columbia University, and the University of Pennsylvania. Following his one-year service in the 484th Air Squadron in France, Sukert moved back to Detroit and worked for famed architect Albert Kahn until he opened his own studio in 1921. Other buildings he designed include Trinity Church, Detroit; Saint Paul's Memorial Church, Detroit; Saint Matthew's Church, Detroit; Christ Church, Flint; Saint Luke's Church, Ypsilanti; and All Saints Church, Pontiac. In addition to the Scarab Club, he held memberships in the Detroit Yacht Club, the Players Club, the American Institute of Architects, and the Michigan Society of Architects. (Courtesy of the Scarab Club Archives.)

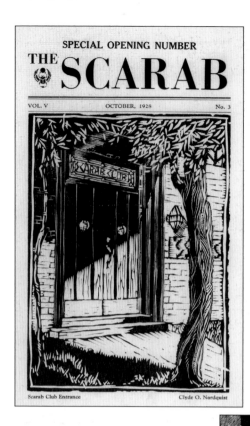

SPECIAL OPENING NUMBER

THE SCARAB

VOL. V OCTOBER, 1928 No. 3

Scarab Club Entrance Clyde O. Nordquist

Albert de Salle wrote in the October 1928 *Scarab*, "The new clubhouse stands as a final and indisputable disproof of the long alleged impracticality of artists in general and Detroit artists in particular . . . the new clubhouse is unique in the fact that it is a concrete expression of the single-minded cooperation of a group of people." Cover design was by Clyde O. Nordquist. (Courtesy of the Scarab Club Archives.)

This 1960s photograph by George R. Booth Jr. portrays the 1928 Scarab Club building. Members were involved at all levels of development. The land was offered by Dexter Ferry Jr. of the Ferry Seed Company at a moderate cost, the financier was Henry Stevens, the architect was Lancelot Sukert, and the contractor was Max Colter. (Courtesy of George R. Booth Jr. and the Scarab Club Archives.)

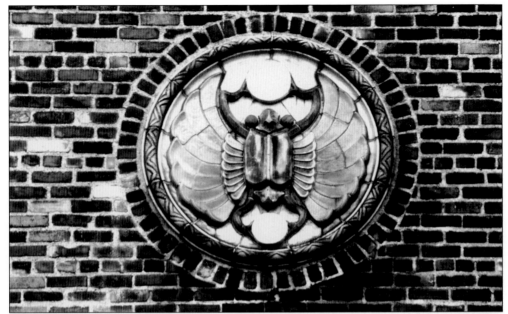

A ceramic scarab adorns the building's facade above the front entrance. It was designed by architect member William Buck Stratton and modeled by sculptor member Horace F. Colby. Pictured in this photograph by George R. Booth Jr. is the blue, green, yellow, and brown glazed scarab decorated and fired at Mary Chase Perry Stratton's (wife of William Buck Stratton) Pewabic Pottery in 1928. (Courtesy of the Scarab Club Archives.)

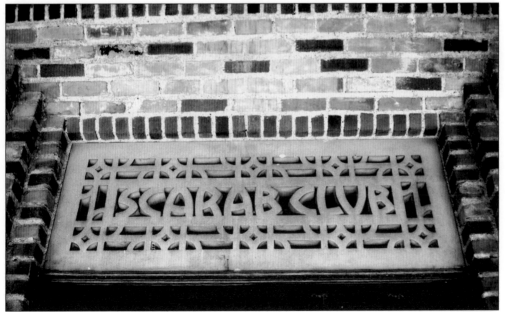

Lancelot Sukert's original building design incorporated the club's name into the building's entrance. Above the two wooden entrance doors a stone was inset with a cut-out decorative border and the words "Scarab Club." The Scarab's pride of finally erecting a permanent clubhouse is proudly announced as visitors approach the doorway. (Courtesy of the Scarab Club Archivist.)

Architectural elements designed and executed by members were the main focus in the 1928 Scarab Club building's design and construction. Some members volunteered to create leaded glass windows for interior doors, which visually describe the use of the rooms beyond. Pictured is the window inset into the door leading into the butler's pantry from the first-floor main gallery. (Courtesy of the Scarab Club Archivist.)

A pay phone booth is hidden behind this leaded window as pictured in this photograph by George R. Booth Jr. Note the old-style, candlestick telephone with the rotary dial on the base, the mouthpiece at the stand's top, the separate earpiece, and the tangle of cords. With the advent and popularity of cellular phones in the 21st century, the pay phone was removed. (Courtesy of the Scarab Club Archives.)

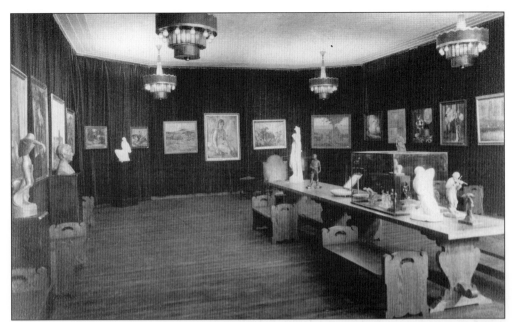

At previous clubhouse locations, exhibition space was limited. Members desired a large main gallery to allow for larger exhibitions. The new clubhouse fulfills this need. To spare the chestnut paneled walls from nail holes, red draperies were hung and pictures suspended on wires from "J" molding specifically manufactured for this purpose. This c. 1928 photograph features a mixed-media exhibition. (Courtesy of the Scarab Club Archives.)

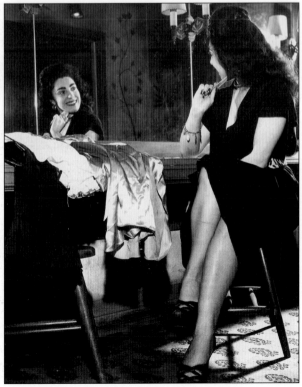

The ladies' restroom is called the "powder puff room" after the leaded glass window inscribed as such and inset into the ladies' room door. This c. 1950s photograph shows a model posing for the photographer with her reflection appearing in the mirror. Note the murals on the reflecting wall, which were a decoration by member Reginald O. Bennett in 1928. (Courtesy of the Scarab Club Archives.)

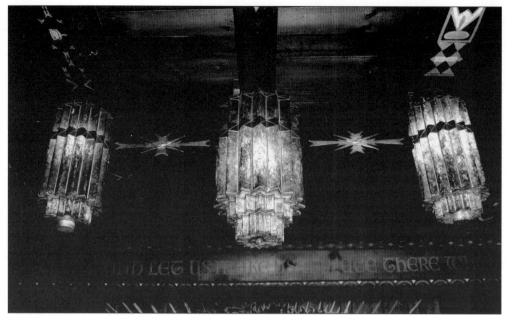

This close-up photograph of the second-floor lounge lighting in the 1928 clubhouse, designed by member Victor Toothaker, shows the mica and metal art deco–style detail. Each light is decorated about one-third of the way from the top with bands of geometric patterns in green and gold paint. Toothaker also designed the lighting in the 1928 photograph of the first-floor gallery on page 31. (Courtesy of the Scarab Club Archivist.)

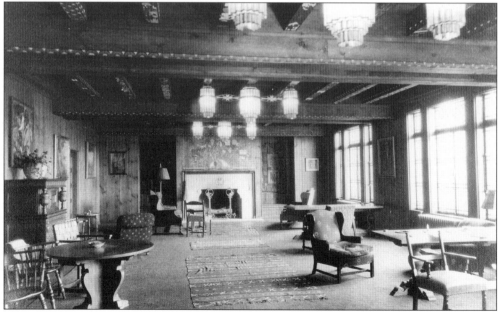

A dream come true for members, this 1928 photograph of the second-floor lounge shows the chestnut lined walls, art deco lighting, and stone fireplace with mural decoration above. Even though this area was limited to members only and the display of art from the permanent collection, the lounge is currently used for members' exhibitions and is open to the public. (Courtesy of the Scarab Club Archives.)

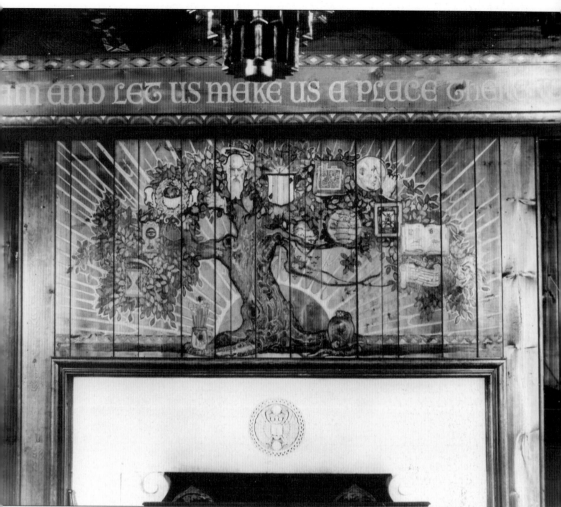

Paul Honore, artist and muralist, designed and executed the Scarab family tree mural above the fireplace in 1928. As Honore painted, member Shu Chai captured the iconic meanings, "Slightly green, in a quiet mouldy [sic] way, the face of the immortal old master [Robert Hopkin] looks out benignly from the topmost boughs . . . Craftsman have their symbol in the hammer-holding hand . . . Scythe and hour-glass give the life members hope for long and pleasant fellowship . . . the eye of the lay member is glued to the keyhole." Displayed on the right-hand side are the mask of drama, score of music, open book for literature, and printer's form and blueprint for graphic arts and architecture. Chai states, "The thumb of a sculptor adds, in ultimate gesture, the finishing touch to a face of clay. Out of town members are remembered over all the globe, which hangs undisturbed near a swarm of winged insects. Paul says these may be busy bees working in harmonious cooperation, but the nest looks dangerously like a hornet's." (Courtesy of the Scarab Club Archives.)

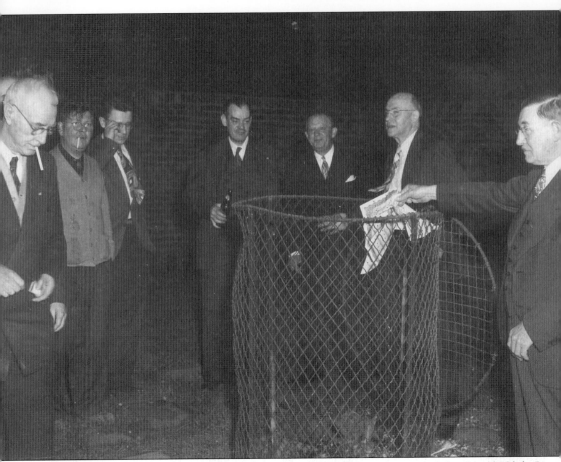

The Great Depression had an adverse effect on the nation's economy and the Scarab Club. In 1928, the club entered into a land contract with Henry G. Stevens and Dexter M. Ferry Jr. for the property and new building construction, with a renegotiation in 1935 after Stevens's death. By 1939, the organization was delinquent on its taxes and land contract and again renegotiated the contract. In 1941, the decision was made to refinance the mortgage by selling 120 bonds in $100 increments at 5 percent interest. In 1947, the club's financial condition improved. All bonds were retired with the exception of $1,400 purchased by Henry T. Ewald, president of the Campbell-Ewald advertising firm, who donated his shares to the club. The October 14, 1947, meeting minutes record treasurer Horace S. Boutell's announcement that "the club mortgage had been paid and suggested that the burning ceremony be held in November." Members celebrated the Bond Burning Party in the garden courtyard and ceremoniously toasted its mortgage-free status. (Courtesy of the Scarab Club Archives.)

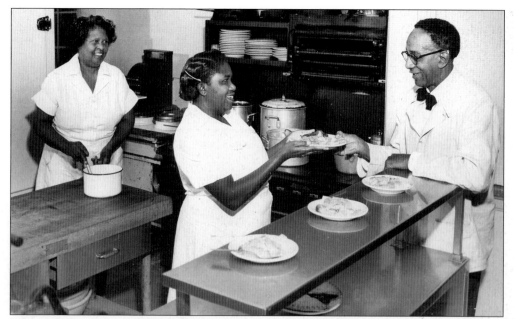

This 1953 Ransier Studio photograph portrays the kitchen and waitstaff who provided the intimate dining experience for members and their guests. Waitstaff were first hired in 1928 when the new building was opened and were an important attribute for the organization. This 1953 Scarab Club marketing publication indicates, "the Club's kitchen is famous for its delectable southern cuisine style." (Courtesy of the Scarab Club Archives.)

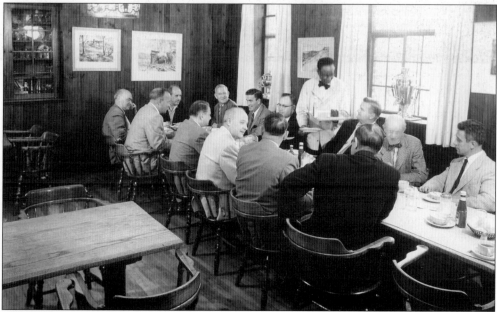

The 1953 publication, *The Founding and Growth of the Scarab Club of Detroit*, featured this 1953 Ransier Studio photograph with the following caption: "One of the most popular areas of the club is the cozy and intimate dining room. Here meals are served to members and their guests at noon and in the evening each Monday, Wednesday, Thursday, and Friday." (Courtesy of the Scarab Club Archives.)

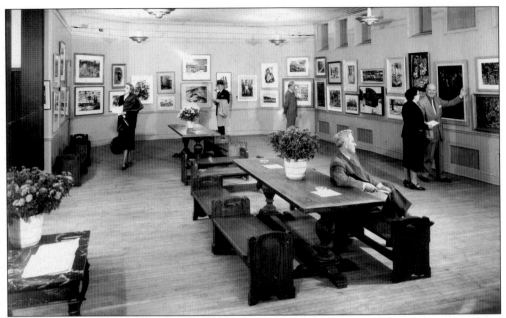

By 1953, the main gallery of the 1928 clubhouse was completely renovated. Modern light fixtures replaced the art deco fixtures. Chestnut paneled walls were covered in canvas and plastered over. A wall between the gallery and an anteroom was removed, which created an expanded exhibition space. The Photographic and Detroit Art Directors' Clubs show their work in this 1953 photograph by Ransier Studio. (Courtesy of the Scarab Club Archives.)

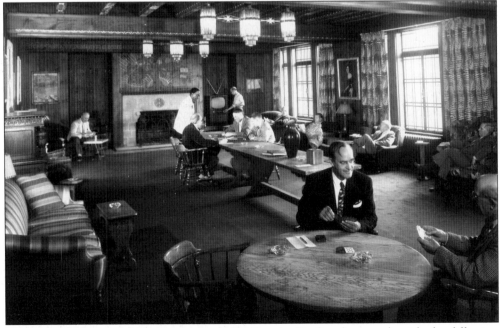

The 1953 marketing publication featured this Ransier Studio photograph with the following caption: "The famous and popular lounge of the clubhouse is the work of the club members. Here you find a distinctive atmosphere unlike that of any other club in Detroit." Members shown enjoy camaraderie through discourse and card games. (Courtesy of the Scarab Club Archives.)

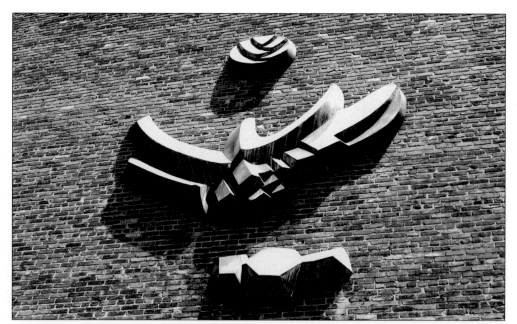

The Phoenix sculpture on the 1928 building's west wall created by Stephen Veresh was honored in a 1976 newsletter. Pres. Fred Moorehouse stated, "Just as the Phoenix was worshiped by the ancient civilizations as a symbol of eternal life, so do we here today dedicate our Phoenix as a . . . symbol of our faith in the rebirth of this nation, this city, and the Scarab Club." (Courtesy of the Scarab Club Archivist.)

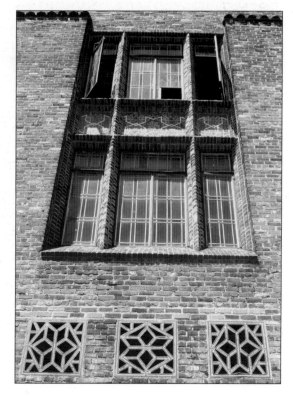

This portion of the building's facade shows the Moorish designed cutout stonework, the leaded glass casement windows, and Moorish decorated mosaics set between the upper and lower windows. These mosaics depicted in original Sukert architectural drawings were not executed until the late 1980s. Detroit artist member Edgar Yaeger, a junior member in 1928 when the building opened, designed, executed, and installed the mosaics. (Courtesy of the Scarab Club Archivist.)

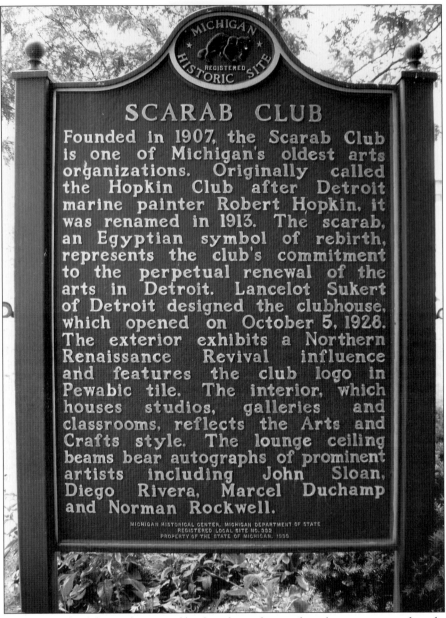

SCARAB CLUB

Founded in 1907, the Scarab Club is one of Michigan's oldest arts organizations. Originally called the Hopkin Club after Detroit marine painter Robert Hopkin, it was renamed in 1913. The scarab, an Egyptian symbol of rebirth, represents the club's commitment to the perpetual renewal of the arts in Detroit. Lancelot Sukert of Detroit designed the clubhouse, which opened on October 5, 1928. The exterior exhibits a Northern Renaissance Revival influence and features the club logo in Pewabic tile. The interior, which houses studios, galleries and classrooms, reflects the Arts and Crafts style. The lounge ceiling beams bear autographs of prominent artists including John Sloan, Diego Rivera, Marcel Duchamp and Norman Rockwell.

MICHIGAN HISTORICAL CENTER, MICHIGAN DEPARTMENT OF STATE
REGISTERED LOCAL SITE NO. 332
PROPERTY OF THE STATE OF MICHIGAN, 1999

In 1974, the Scarab Club was threatened by demolition for a parking lot to accommodate the new Detroit Science Center. Members rallied and appeared before Detroit's city council to present their case of opposition. The council agreed with the club, and the building was safeguarded. To ensure its future preservation, members filed the appropriate forms with the State of Michigan, which resulted in the building's listing on the State of Michigan's Historic Register on July 26, 1974, and the state marker's installation in 2000. The City of Detroit designated the Scarab Club as its own Local Historic District on July 18, 1979. The National Register of Historic Places entered the Scarab Club on its list on November 20, 1979, for its outstanding historical and architectural significance. The national historic plaque was installed and dedicated in April 1997. Dr. Jerald Mitchell arranged for and donated the foundry costs for both markers and scripted the text on the state historic marker with board approval. (Courtesy of the Scarab Club Archivist.)

Three

PROMINENT MEMBERS

What do art and notables have in common? They are Scarabs, of course! Founders were the lifeblood. Although no formal list was kept, the recollection of Clyde Burroughs in the *Scarab Club Bulletin*, October 1928, lists the earliest members of the Hopkin Club as "James Swan, Joseph Gies, Albert Peters, Clyde Burroughs, Charles Waltensperger, Roman Kryzanowsky, John Morse, Horace Boutell, and Gustav Schimmel. Within one year, several more made the club's acquaintance, including Frank Scott Clark, D. M. VanRiper, Roy C. Gamble, James May, Fred Huetwell, George True, Charles King, Ivan Swift, Henry Kruger Jr., R. E. Heinrich, Charles Culver, Carl Bender, Paul Honore, and Harry Woodhouse."

As the club grew, prominent business leaders and artists joined the Scarab ranks. Members included significant realtors Guy Greene, Walter C. Piper, Henry G. Stevens, and John Tigchon; Cranbrook founder and newspaper owner George Gough Booth; Ferry Seed Company owner Dexter M. Ferry Jr.; automotive pioneers Edsel Ford and Charles and Lawrence Fisher; architects Albert Kahn and William Buck Stratton; Cambell-Ewald president Henry T. Ewald; developer Alfred Taubman; prominent business leaders Herbert V. Book, Frank C. Hecker, Joseph M. Dodge, Edgar B. Whitcomb, Robert H. Tannahill, Harold du Charme; predominate Detroit Institute of Arts staff Armand Griffith, William Valentiner, Edgar P. Richardson, Willis Woods, Fred Cummings, James W. Tottis, and Ronald Miller; notable artists, some honorary, included Julius Rolshoven, Mathias Alten, Myron Barlow, Samuel Halpert, Francis Petrus Paulus, John Carroll, Zoltan Sepeshy, William Bostick, Marshall Fredericks, Eliel Saarinen, Carl Milles, Van Cliburn, Sarkis Sarkisian, F. Carlos Lopez, and Jay Boorsma.

Women were officially admitted as members in 1962. Two honorary life members were elected on November 12, 1962: Eleanor Ford and Florence B. Davies. Charter women members were elected on December 11, 1962: Miriam S. Aston, Florence Maiullo Barnes, Winifred Klarin, Maria Lalli, Elizabeth H. Payne, Reva C. Shwayder, Irene S. Toth, Lydia K. Winston, and Eva Worcester.

The above is just a sampling. Over 3,000 members contributed support, volunteer time, and artistic talents over the organization's 100-year history. It is the membership who helps to continue the prosperity of the Scarab Club.

Myron Barlow (1873–1937) was described by Clyde Burroughs in the Detroit Institute of Arts' (DIA) 19th Annual American Art Exhibition catalog, "With the death of . . . Barlow . . . Detroit saw the passing of the last of an older generation of artists . . . [Barlow] brought distinction to his native state." Barlow donated this painting for a club raffle and photograph for the 1917 *Scarab* magazine. (Courtesy of the Scarab Club Archives.)

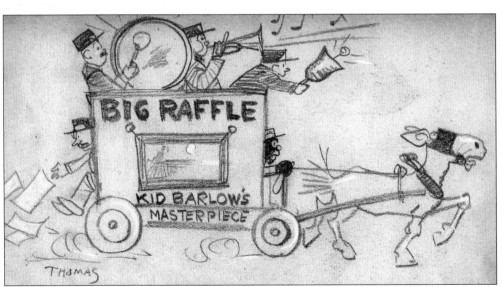

Burt Thomas, cartoonist for *Detroit News*, captured the spirit of the Barlow raffle in the 1917 *Scarab* magazine. Incidentally, Myron Barlow started his artistic career as a newspaper illustrator. Both Barlow and Thomas were early members of the Scarab Club and contributed their handiwork for the collaborative Scarab publication. (Courtesy of the Scarab Club Archives.)

William A. Bostick (born in 1913) first joined the Scarab Club in 1939 and is currently a member after 67 years. A prominent watercolorist, he is noted for images of buildings in Detroit, particularly Old Main at Wayne State University, the DIA, and the Scarab Club. A lifelong leader in the arts community, he served as the DIA museum secretary from 1946 to 1976 and Scarab president from 1962 to 1963. When he served during World War II, Bostick rendered the topographical maps that aided in the invasion of Normandy recently featured in a *National Geographic* magazine article. Bostick is well known for presiding over the meeting where women were finally allowed club membership in 1962. In this 1980s photograph by George R. Booth Jr., pictured are, from left to right, Mariam S. Aston, William A. Bostick, and Florence Maiullo Barnes. Aston and Barnes were admitted as charter women members in December 1962. (Courtesy of the Scarab Club Archives.)

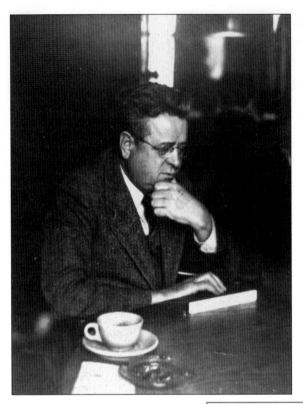

Clyde Burroughs (1882–1973), Hopkin Club founding member and 1926 Scarab Club president, served as the museum director and the first curator of American art at the DIA. Through a series of American art exhibitions, he built the museum's collection and fostered personal relationships with many Ashcan School and late American impressionist artists. (Courtesy of the Scarab Club Archives.)

Samuel Cashwan (1900–1988), the Russian-born sculptor rendered for the November 1930 *Scarab* by Reginald O. Bennett and featured in the "What Is Art?" column, responded, "Art is the skillful expression thru some medium of a personal reaction to a phase of life. The main purpose in art creation is the pleasure of the emotion and the mind—Aesthetic and Kinetic pleasures." (Courtesy of the Scarab Club Archives.)

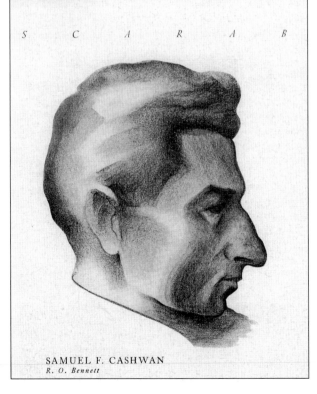

S C A R A B

SAMUEL F. CASHWAN
R. O. Bennett

Frank Scott Clark (1865–1937), a well-known photographer who had a home and studio on Cass Avenue, was a founding member of the Hopkin and Scarab Clubs and president from 1919 to 1920 and again from 1923 to 1924. Many photographs used in this publication were taken by Clark and donated to the club by him and other members. This photograph was taken around 1937. (Courtesy of the Scarab Club Archives.)

Roy C. Gamble (1887–1972), founding and lifelong member of the Hopkin and Scarab Clubs, is pictured in this 1930 George W. Styles photograph. Gamble was a portrait painter who portrayed images of judges, civic, and social leaders and executed impressionist-style landscapes. In 1925, he painted six Detroit early history murals for the *Detroit News* that were later moved to the Free Press Building. (Courtesy of the Scarab Club Archives.)

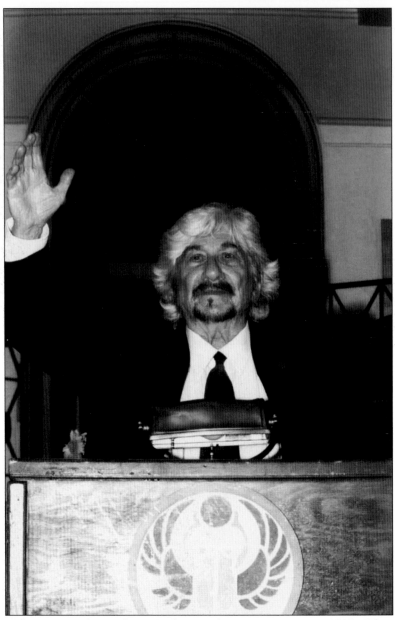

Pablo Davis (born in 1917) stated in a Web journal entry on August 4, 2005, "This is the way it works in America for an artist. In order to survive with your painting you have to work on many jobs; some of them menial, low-paying, just to keep you and people who depend on you, alive. A big part of my artistic life was the time I spent with Rivera and Kahlo." Davis, an artist and community activist, first came to Detroit in 1932 and assisted Diego Rivera with the Detroit Industry murals at the DIA. During this time, Davis lived with Rivera and Frida Kahlo. His most memorable mural contribution was a Dick Tracy image on the south wall. Davis is pictured in a Patricia Reed photograph addressing the community at the Scarab Club about his life's ambitions in May 2001. As a community activist, he donated his art to Bridging Communities to raise funds for the development of an intergenerational center next to the Pablo Davis Elder center in southwest Detroit. (Courtesy of the Scarab Club Archives.)

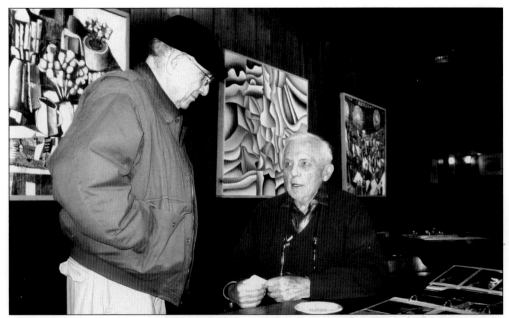

Peter Gilleran (born in 1921) is a prolific artist who studied at Colorado College and Cranbrook Art Academy and retired in 1989 as an art professor at Wayne State University. He currently paints in his Pontiac studio. Pictured in this Patricia Reed photograph of the Gilleran lounge exhibition are, from left to right, Sam Karres and Peter Gilleran discoursing about the exhibition and their previous art liaisons. (Courtesy of the Scarab Club Archives.)

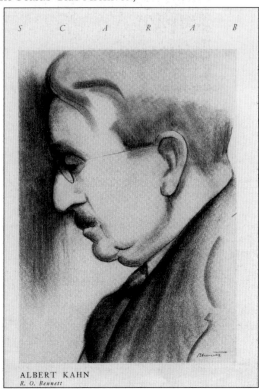

Albert Kahn (1869–1942), an architect who designed the Fisher and General Motors buildings, Detroit Athletic Club, Detroit Free Press and Detroit News buildings, and the Ford River Rouge Plant, was sketched by Reginald Bennett for the October 1930 *Scarab* where Albert de Salle stated, "[Kahn enriched] the architectural beauties of the city far beyond the efforts of any other one man." (Courtesy of the Scarab Club Archives.)

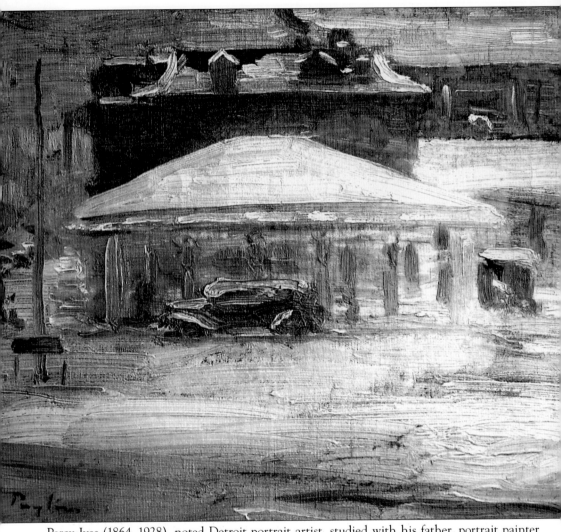

Percy Ives (1864–1928), noted Detroit portrait artist, studied with his father, portrait painter Lewis T. Ives, and at the Pennsylvania Academy of Fine Arts, Academie Julian, and Ecole des Beaux-Arts. Ives taught and served as dean at the Art School at the Detroit Museum of Art. His portrait commissions included governors, senators, and mayors. Noted in the *Scarab Club Bulletin*, March 1928, "the last picture which he painted, a winter scene painted from his window, was a transcript of nature with an astonishing freshness of vision For more than two decades he served as an artist member of the Board of Trustees of the Detroit Museum of Art. He was for many years a member of the Scarab Club and was one of the most frequent visitors to the sketch class." Pictured is his last painting from the winter storm of January 1928. (Courtesy of Randell and Patricia Reed.)

Ernest Junker, pictured in 1948, was the manager of the Scarab Club from 1929 until his 1974 retirement, serving its members in his humble fashion. James Taliana, president, in the vacation edition of the autumn 1974 *Scarabuzz* called Junker "Mr. Scarab Club." Since the club's inception, Junker was the longest employed manager and was invited to sign the lounge beams as an honor. (Courtesy of the Scarab Club Archives.)

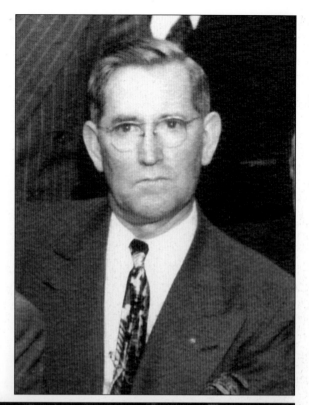

Sam Karres (born in 1929) is a two-time Scarab Gold Medal Award winner in 1977 and 2004. Pictured in this Patricia Reed photograph is Karres at the book signing of his biography *Sam Karres - Urban Expressionist* by James F. Bloch in the Scarab Club lounge. Karres, a retired automotive illustrator, still paints in watercolor and oil and has a studio in Royal Oak. (Courtesy of the Scarab Club Archives.)

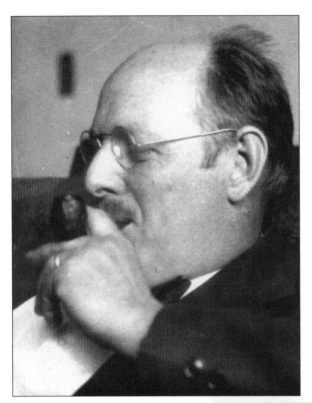

Floyd Nixon (1890–1972) is featured in this 1930 George W. Styles photograph, which is almost a caricature in nature. Nixon was an illustrator with the *Detroit Free Press* who enjoyed capturing caricature cartoons of others. He was a Scarab Club member from 1924 until his death. (Courtesy of the Scarab Club Archives.)

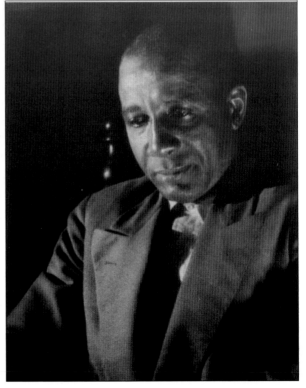

John Payne (1892–1957) was the caretaker of the Scarab Club from the time the Farnsworth clubhouse was built. The original plans included a ground-floor apartment for Payne and his wife, Bertha. During his tenure, he trained and supervised the waitstaff and joined in member functions. The seriousness of his duties was captured by George W. Styles in this 1930 photograph. (Courtesy of the Scarab Club Archives.)

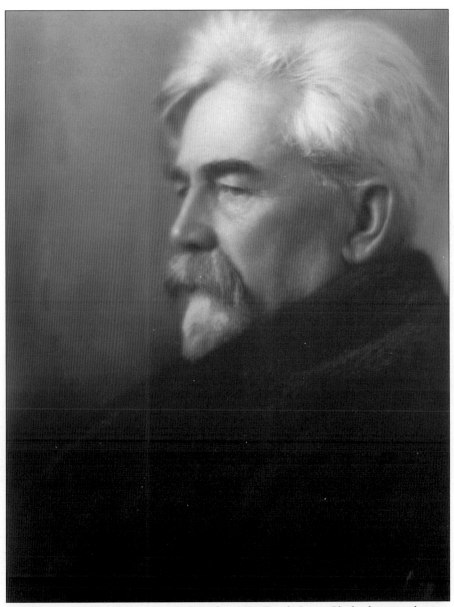

Julius Rolshoven (1858–1930) is featured in this 1914 Frank Scott Clark photograph, signed to Louis Kamper, a leading architect whose wife was a portrait subject. Rolshoven studied in New York at the Cooper Union and Plessman Academy and in Germany at the Düsseldorf Academy. He mostly lived abroad in London and Paris and maintained a studio in Italy. In Detroit, following his death, Rolshoven was memorialized as part at the 17th Annual Exhibition of American Art at the DIA; a smaller gallery was set aside to display his work. Burroughs wrote of Rolshoven in the catalogue's foreword, stating, "A stalwart apostle of that sturdy painting which had its inception in Munich in the last quarter of the nineteenth century, a movement which developed under the inspiring leadership of Frank Duveneck who had as his associates such men as William M. Chase, John W. Alexander, John Twachtman, . . . Rolshoven, all of whom in passing have left their impression on American art." (Courtesy of Randell and Patricia Reed.)

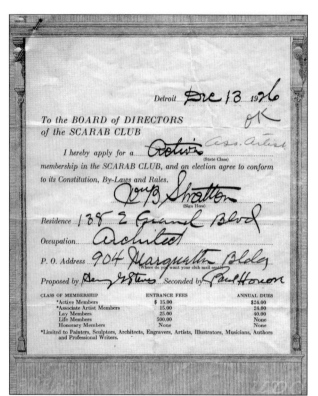

William Buck Stratton (1865–1938) trained as an architect at Cornell University, moved to Detroit in 1893 to form a partnership with Frank C. Baldwin, and was a founding member of the Detroit Society of Arts and Crafts. Stratton was invited to join the Scarab Club in 1926, as seen in the application, as part of the membership drive to raise funds for the new clubhouse. (Courtesy of the Scarab Club Archives.)

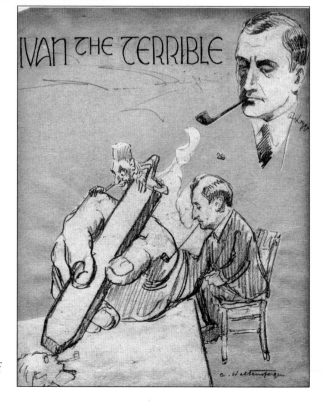

Ivan Swift (1873–1945), an artist and writer, is pictured in this February 1914 *Scarab* magazine sketch. Swift was jokingly called "Ivan the Terrible" for his harsh art exhibition critiques. Other than painting, Swift is best known for his poetry publications, *The Blue Crane* and *Fagots of Cedar*. He was an early member of the Scarab Club who was later bestowed an honorary membership. (Courtesy of the Scarab Club Archives.)

Four

EXHIBITIONS

How has an arts club, founded in 1907, maintained a tradition in exhibiting material that exemplifies and promotes art from the state of Michigan? Prior to the advent of the Scarab Club, many of the artists who helped in the club's formation had established reputations and exhibited at the DMA, the precursor to the DIA. The Exhibition of the Work of Michigan Artists was held at the DMA in October 1890 and another for Michigan artists in October 1905. Among exhibitors were future Hopkin/Scarab Club members. Robert Hopkin had two solo exhibitions dedicated to his work: Mr. Robert Hopkin's Collection of Paintings, May 1901, and Loan Collection of the Paintings of Mr. Robert Hopkin Owned in Detroit, November 1907. Two other notable Scarabs who had solo shows at the DMA were C. Harry Allis in December 1896 and Francis Petrus Paulus in November 1902.

The DIA began the Annual Exhibition of American Art (1915–1931, 1937, 1938) where several talented Scarabs exhibited. The primer exhibition that forever ties the Scarab Club and the DIA together is the Annual Exhibition of Michigan Artists (1911–1973). It was held under the joint auspices of the Scarab Club and the DIA from 1911 to 1928. As stated in the 1929 *Annual Exhibition* catalog, "the Scarab Club expressed a desire to withdraw from active participation . . ., believing that the state-wide growth of interest had reached a point where one organization of artists should not have the sole voice."

The Scarab Club Gold Medal was the top prize of the Michigan Artist Exhibitions until it withdrew. The medal was awarded sporadically at the DIA and the club through the 1930s. It continues to be the club's highest annual award.

Exhibitions held during the last century include the Silver Medal (begun in the 1940s), Advertising Art, Photography, Water Color, Printmaking, and Sculpture among others. Most exhibitions continue to be juried by predominant members of the art community both local and national. Other exhibitions are by exclusive invitation, the artist having earned a prominent reputation in local or national art.

FIRST ANNUAL EXHIBITION

BY THE

Hopkin Club Painters

DECEMBER 4th TO 31st
1911

The Museum is open to the public free, every week day
from 9 a. m. to 4 p. m; on Sundays from 2 to 4 p. m.

The 1911 First Annual Exhibition of Hopkin Club Painters had 17 participants who lent 153 artworks. The catalog announces, "the City of Detroit and the Detroit Museum of Art are under many obligations to the artists of the Hopkin Club from whom so many and valuable paintings are borrowed for this exhibition." Hopkin Club exhibitions were also held in 1912 and 1913. (Courtesy of the Detroit Institute of Arts.)

The Scarab Club's 1915 Annual Exhibition of Pictures by Michigan Artists at the DMA was the second juried exhibition for all Michigan artists. There were 242 artworks exhibited by 65 artists. The catalog states, "From a group exhibition of a few leading men painters, the scope of the exhibit was broadened to embrace the entire coterie of Michigan Painters." (Courtesy of the Scarab Club Archives.)

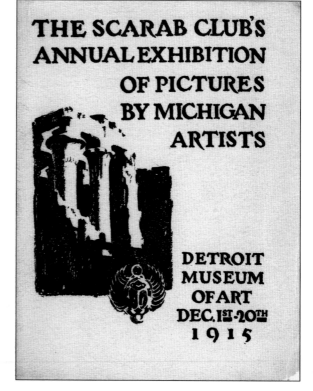

THE SCARAB CLUB'S
ANNUAL EXHIBITION
OF PICTURES
BY MICHIGAN
ARTISTS

DETROIT
MUSEUM
OF ART
DEC. 1ST-20TH
1915

The catalog of 1915 *Michigan Art Exhibition for War Sufferers* explains, "the committee in charge of the [exhibit] is deeply grateful to the artists of Michigan for their most generous donations and hearty cooperation . . . the desire . . . is that all people may cooperate with artists in their efforts to be of service to the Red Cross work abroad." Scarabs were major contributors. (Courtesy of the Scarab Club Archives.)

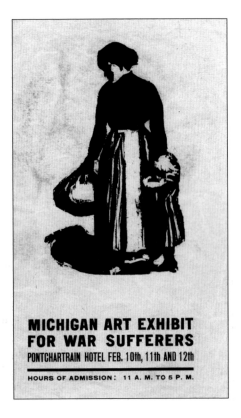

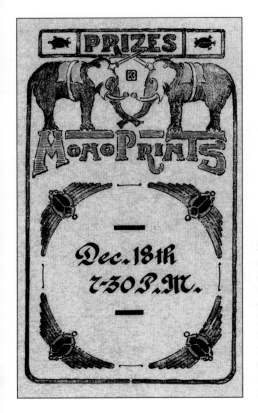

Special exhibitions of members' work were scheduled in the clubhouse and at various outside locations. This postcard announced to the membership the opportunity for prizes for works submitted to the December 18, 1915, Monoprints exhibition held at the Witherall Street clubhouse. The card was discovered in the 1915 *Scarab* magazine. Note the designed scarabs, both winged and at rest, which represent the club's name. (Courtesy of the Scarab Club Archives.)

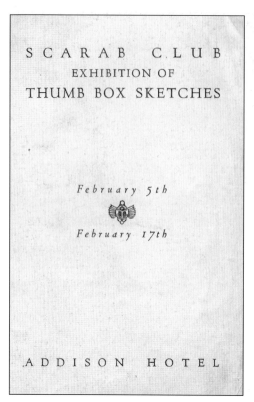

SCARAB CLUB

EXHIBITION OF

THUMB BOX SKETCHES

February 5th

February 17th

ADDISON HOTEL

The 1917 Scarab Club Exhibition of Thumb Box Sketches celebrated the new club location at the Addison Hotel. It consisted of a mixed media of art by 12 Scarab members: A. A. Besel, Joseph W. Gies, Roman Kryzanowsky, Arthur A. Marschner, John A. Morse, E. C. Rein, F. W. Rypsam, Harry Smith, Ivan Swift, George A. True, Charles E. Waltensperger, and Paul Honore. (Courtesy of the Scarab Club Archives.)

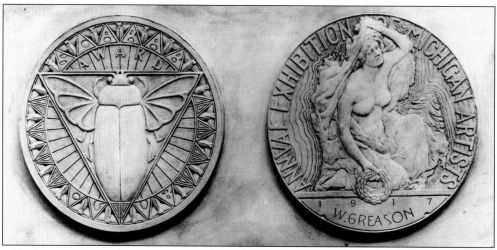

Alfred Nygard (born in 1894), sculptor, designed the first gold medal for the Scarab Club's top award at the Annual Exhibition of Michigan Artists while Frederick Zeigen was the financial sponsor. The medal was first awarded in 1917 to William Greason, Scarab member, for a group of landscapes juried into the exhibition. This award is still given annually at the members-only Scarab Club Gold Medal exhibition. (Courtesy of the Scarab Club Archives.)

The second gold medal from the Annual Exhibition of Michigan Artists under the Auspices of the Scarab Club was awarded to Joseph W. Gies in 1918 for his oil portrait of photographer and Scarab Club president Frank Scott Clark. This painting, displayed at the Scarab Club, was donated to the organization in 1946 following the death of his wife, Mary Clark, by Annie Ward Foster, her sister. (Courtesy of the Scarab Club Archives.)

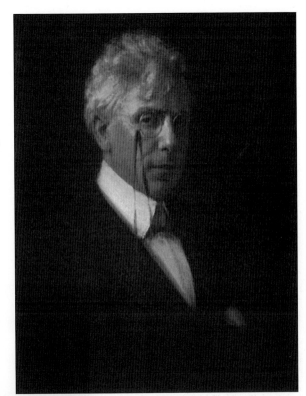

The 1929 Annual Exhibition of Michigan Artists Scarab Gold Medal was awarded to Iris Andrews Miller, the second female to receive this honor, for her oil portrait titled "Mary." In 1987, this painting was donated to the club by Miller's granddaughter, Mrs. Ellis Merry, following the Women Artists at the Scarab Club 1914 to 1987 exhibition organized by Thomas W. Brunk. (Courtesy of the Scarab Club Archives.)

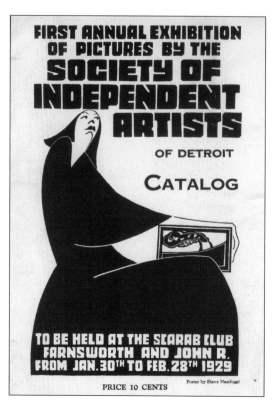

FIRST ANNUAL EXHIBITION OF PICTURES BY THE SOCIETY OF INDEPENDENT ARTISTS OF DETROIT

CATALOG

TO BE HELD AT THE SCARAB CLUB FARNSWORTH AND JOHN R. FROM JAN. 30TH TO FEB. 28TH 1929

PRICE 10 CENTS Poster by Steve Nastfogel

The first exhibition by the Society of Independent Artists was held at the Scarab Club in 1929. Steven Nastfogel designed the cover. When asked about the non-juried exhibit, founder and president Philip Ayer Sawyer stated, "We hope to give the newly formed institution a civic character, feeling that the artist and his work is an integral part of the life of the city." (Courtesy of the Scarab Club Archives.)

Although the third annual 1931 exhibition of the Society of Independent Artists was held at the Gordon Galleries, the Scarab Club was listed as the organization's headquarters. The show did not offer prizes, nor was it juried, so all artists had the opportunity to publicly display their work. The officers were Scarabs, including Pres. Jay Boorsma, Vice Pres. William Fanning, and secretary-treasurer Walt Speck. (Courtesy of the Scarab Club Archives.)

THIRD ANNUAL
EXHIBITION

SOCIETY INDEPENDENT ARTISTS

JANUARY 13th to 31st
1931
GORDON GALLERIES
37 E. ADAMS AVENUE
DETROIT, MICH.

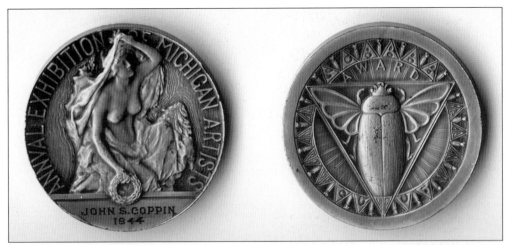

By 1940, all Gold Medal Awards were solely given at the Scarab Club exhibition each year. In 1944, the displayed medal was awarded to John S. Coppin, whose name is engraved on the front. Note the symbol of Michigan on the front side representing the Annual Exhibition of Michigan Artists for which the medal was designed. The Scarab Club is represented on the back. (Courtesy of Randell and Patricia Reed.)

John S. Coppin won a total of three gold medals, one each in 1940, 1944, and 1946, one of the few artists to win multiple medals. The painting *Pandora's Box* was the 1940 gold medal winner in the Scarab Club Annual Exhibition. It was painted while he maintained a studio on the third floor of the Scarab building. (Courtesy of Randell and Patricia Reed.)

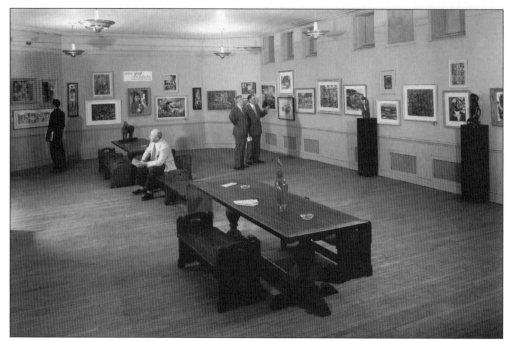

The Art Instructors of the Detroit Public Schools exhibition was captured in 1953 by Ransier Studios. The Scarab Club partnered with other organizations by arranging for exhibitions such as this one. Another organization, the Detroit Society of Women Painters and Sculptors, exhibited almost annually at the club since the building's construction in 1928. (Courtesy of the Scarab Club Archives.)

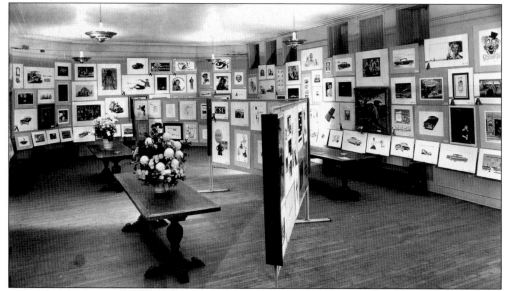

The Advertising Art Exhibition was another 1953 exhibition photographed by Ransier Studios. During the 1940s and 1950s, a large number of members were employed or freelanced in the advertising industry. According to a marketing brochure, "The Art Director's Club [hosts an] annual exhibit of advertising art among the nation's best. The Award Dinner which accompanies this event is one of the club's gala occasions." (Courtesy of the Scarab Club Archives.)

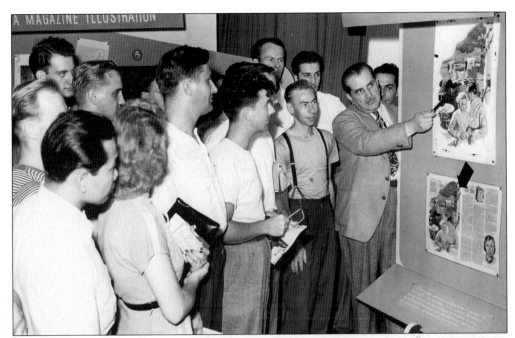

One of most prominent exhibitions, the Advertising Art Exhibition in the mid-1950s shows the enormity of work entered into the show. Illustrators were excited and honored to submit their original work for public display. Usually the general public only sees this type of work in newspaper advertisements, magazines, and brochures. (Courtesy of the Scarab Club Archives.)

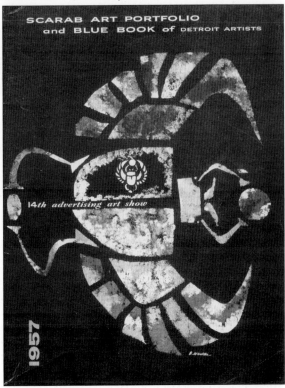

Pictured is the cover of the 1957 *14th Advertising Art Show, Scarab Art Portfolio and Blue Book of Detroit Artists*. According to Robert C. Barfknecht, Scarab president, "We produced our first catalog of Detroit Advertising Art [last spring]. Since then . . . a much more important catalog [took] form . . . the Scarab Art Portfolio and Blue Book, and you are looking at Volume One, Number One right now." (Courtesy of the Scarab Club Archives.)

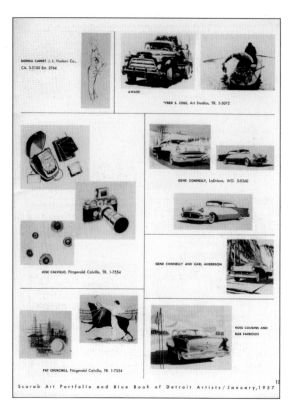

Pictured is page 13 from the 14th Advertising Art Show catalog illustrating an award-winning advertisement by Fred S. Cole. Other illustrations include a fashion sketch by Norma Carrett; automotive advertisements by Ross Cousins, Bob Farbolin, Gene Connelly, and Karl Anderson; and camera and other advertisements by Jose Calvillo, Pat Churchill, and Fitzgerald Calvillo. (Courtesy of the Scarab Club Archives.)

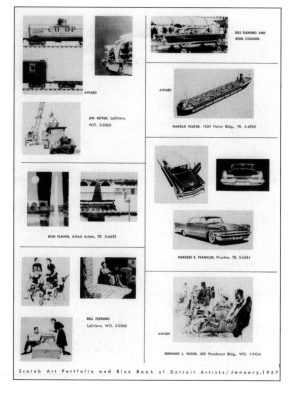

Page 19 of the 14th Advertising Art Show is a sampling of illustrations by three award winners, Jim Fetter from LaDriere, Howard Flucke from the Fisher Building, and Bernard L. Fuchs from the Penobscot Building. Other artists featured are Bill Fleming from LaDriere, Ross Cousins and Don Flavin from Allied Artists, and Burgess E. Franklin from Prucher. (Courtesy of the Scarab Club Archives.)

The 15th Advertising Art Show was "judged by a committee from the Detroit Art Directors Club A major portion of the national expenditure for art and design is spent in Detroit . . . much of the credit for developing this fine market belongs to the Scarab Club and its annual art shows," indicated Warren Kemp, Art Directors Club of Detroit president. Page 5 is pictured. (Courtesy of the Scarab Club Archives.)

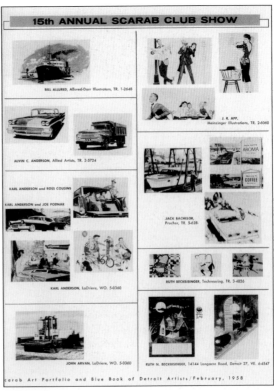

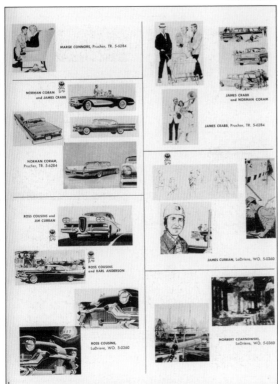

The 1958 *Scarab Art Portfolio and Blue Book of Detroit Artists*, 15th Advertising Art Show, was $1 per copy. Page 8 is featured with award ribbons indicating the prize winners Norman Coram and James Crabb, Ross Cousins and James Curran, and Ross Cousins and Karl Anderson. Other featured illustrators are Marge Connors and Nobert Czarnowski. (Courtesy of the Scarab Club Archives.)

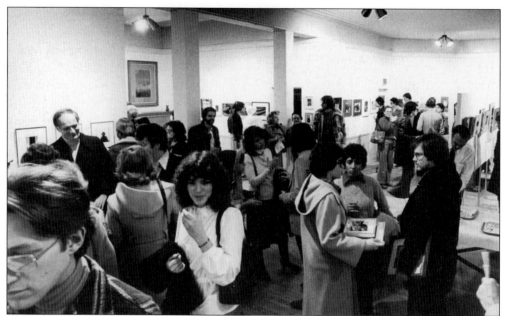

Gallery exhibition openings and artist receptions are a way of bringing artists, patrons, and the general public together to view the latest creations and ideas. A full house is pictured during the 1970s. Note the newest 1970s high-tech gallery lighting fixtures, a modern replacement from the 1950s models, and a big change from the 1928 art deco fixtures. (Courtesy of the Scarab Club Archives.)

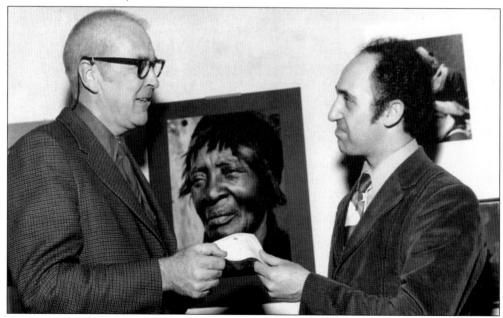

Every juried exhibition provides artists with the opportunity to compete for prizes, usually monetary. Pictured here is Richard Shirk presenting James Taliana with a prize at a 1970s photography exhibition. The Photography Group, responsible for promoting this show, has been an important participating group at the Scarab Club since the early days. (Courtesy of the Scarab Club Archives.)

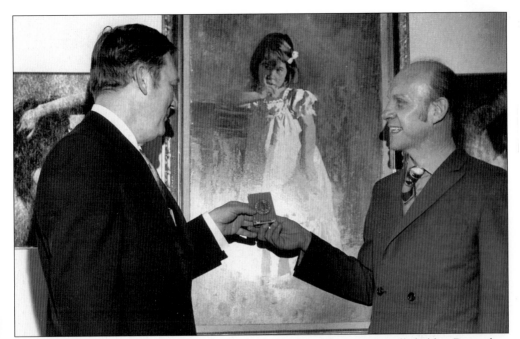

The Gold Medal Exhibition is an annual, members-only exhibition generally held in December. Pictured is Joe Maniscalco receiving one of his awards in the 1970s. Maniscalco won the gold medal four times in the years 1970, 1976, 1986, and 1997, indicating his lifelong achievement of success as a portrait painter. (Courtesy of the Scarab Club Archives.)

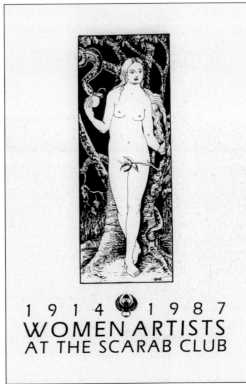

1 9 1 4 · 1 9 8 7
WOMEN ARTISTS
AT THE SCARAB CLUB

Women Artists at the Scarab Club 1914 to 1987, cover art by Caroline Foster, was held during the Festival of the Arts in the fall of 1987. According to organizer Thomas W. Brunk, the exhibit "is intended to examine the rich contributions made by early women artists of the century in Michigan and to honor the much valued women members of the club." (Courtesy of the Scarab Club Archives.)

Fifty Years
of
Scarab Club Art
1907–1957

at the Scarab Club
April 4 - May 4, 1997

Fifty Years of Scarab Club Art, 1907 to 1957, organized by Randell and Patricia Reed and Greg Stephens coincided with the 90th Anniversary of the inception of the Hopkin Club. Patricia Reed stated, "The artwork represented . . . is from a handful of Scarab artists whose lives span several decades of the club's colorful years weaving thoughts, ideas from one generation to the next." (Courtesy of the Scarab Club Archives.)

Arts Midland • January 10 – March 22, 1998

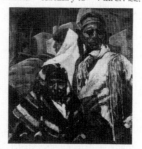

THE SCARAB CLUB
A FELLOWSHIP OF THE ARTS IN DETROIT'S CULTURAL CENTER
217 FARNSWORTH • DETROIT, MI 48202 • (313) 831-1250

Artists of the Scarab Club at Arts Midland was arranged in 1998 by Patricia Reed and Greg Stephens. Patricia Reed stated, "The few living artists whose work are on display have links to the past and are modern day reminders of the rich Scarab heritage which includes camaraderie, activities, class, exhibitions, and discussions." Scarab artists from the club's inception were included. (Courtesy of the Scarab Club Archives.)

William Murcko won the Gold Medal Award in 2001, the same year he served as Scarab president. Pictured is the award-winning painting, a self-portrait in a straight jacket, inspired by a photograph shoot organized by his photographer son highlighting the "seven deadly sins," not by the presidential stress. Murcko wore the straight jacket around New York City while posing at several locations. (Courtesy of the Scarab Club Archives.)

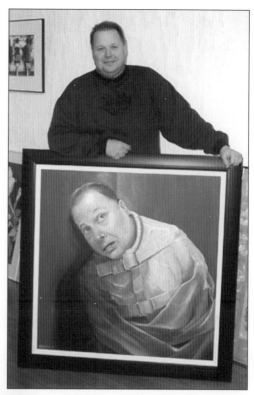

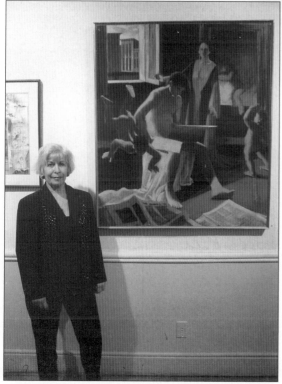

Katherine Arredondo is pictured in this Patricia Reed photograph with her best of show painting, *A Space In Between*, at the Urban Scene Exhibition in April 2003. This exhibition was a partnership between the Scarab Club and the Arts League of Michigan through a grant from the Michigan Council for Arts and Cultural Affairs and the National Endowment of the Arts. (Courtesy of the Scarab Club Archives.)

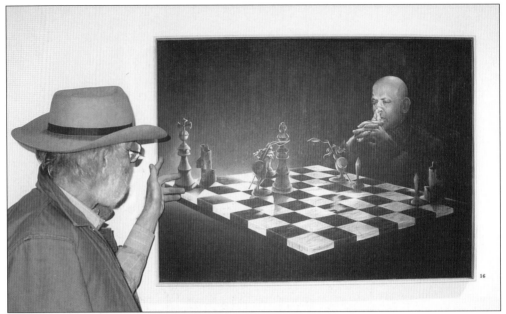

G. Jesse Gledhill is pictured with his first-place painting in this Patricia Reed photograph at the Urban Scene Exhibition in April 2003. The Scarab's partnership with the Arts League of Michigan provided for two art exhibitions and four cultural events. The Urban Scene name was chosen as a theme to create inner-city awareness among the populace of metropolitan Detroit. (Courtesy of the Scarab Club Archives.)

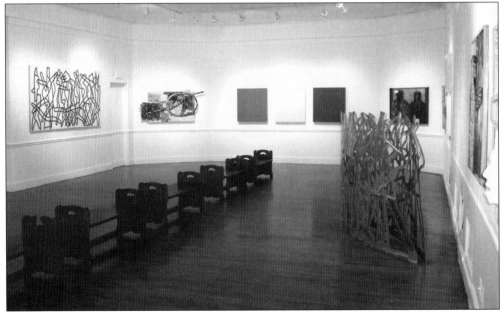

The main gallery featured the Charles McGee and Al Hinton exhibition, Paths Still Searching, in September 2005. In the catalog, Charles McGee states that, "every piece of every artist's work is a marker along the path of his maturation." This exhibition was the first in the newly painted gallery with updated gallery lighting donated by Lightolier, Richard and Jane Manoogian Foundation, and Marsh. (Courtesy of Christine Renner.)

Five

BEAM SIGNATORIES AND DECORATIONS

Where can the curious admire original autographs of some of the most recognizable names in 20th-century art and mural-like decorations? An interesting aspect of the Scarab Club is in its second-floor lounge where a visitor can simply look up to enjoy this treasure. Beams running north to south were decorated by member artists. Information about these beams was ascertained from a reoccurring section in the Scarab Club newsletter called "From the Easy Chair" by Shu Chai, who stated, "Resuming our earlier efforts to make record of the beams in the Club lounge before it shall be forgotten who painted which and why." Floyd Nixon's beam called "Long Drought" or "Reign of Terror" addresses misconceptions about the club. Chai explained, "The Scarabs were . . . serious artists, and it was unfair that the public should regard them only as a band of carousing bohemians." Nixon's beam included images of intolerance, such as a blue nose, black umbrella, and the "crepe-bound hat" of the reformer. Phil Sawyer's beam pays homage to "Life Class [drawing]" that naturally embraces the human figure with two reclining nudes at the center. An Egyptian man and women are conventionally posed to accommodate the given space, a possible salute to the club's name.

During the last 78 years, the ceiling beams were inscribed over 250 times and bear signatures by artists and patrons with local, national, and international reputations who were bestowed this honor. The tradition, lovingly called "signing the guest book," began shortly after the 1928 opening of the Farnsworth building. Famous signers include artists Charles Burchfield (1893–1967); Marcel Duchamp (1887–1968); Rockwell Kent (1882–1971); Walt Kuhn (1877–1949); Reginald Marsh (1898–1954); Diego Rivera (1886–1957); Norman Rockwell (1894–1978); and John Sloan (1871–1951); William G. Milliken (born in 1922), Michigan governor from 1969 to 1983; a popular Detroit Lions football player turned actor, Alex Karras (born in 1935); and former Scarab presidents. John Sinclair (born in 1941), a famed political activist and author, recently signed on November 4, 2004. All in all, the beams continue to serve as a guest book for important personalities, both visiting and homespun.

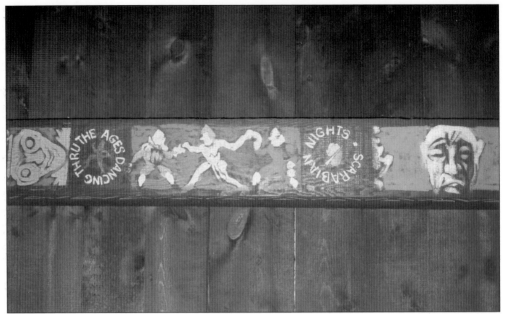

"Let us take thence every man a beam, and let us make us a place there, where we may dwell" is the motto inscribed on a beam over the fireplace. Decorated beams depict the club's history prior to 1928. Pictured is a portion of the ball beam decorated by Sidney Walton representing the balls themed Dancing Thru the Ages in 1921 and Scarabean Nights in 1924. (Courtesy of the Scarab Club Archives.)

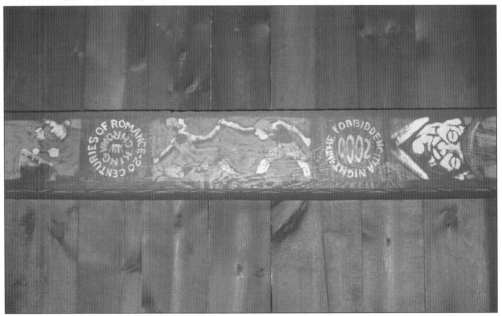

Sidney Walton captured additional balls in this image. A drummer is making music only the couple can hear while they "dance up a storm" at an unseen ball. Walton depicts the 1920 event themed Night in the Forbidden City 2000 where guests dressed in costumes suited for the Orient in the next century. The 1922 Twenty Centuries of Romance is the other featured ball. (Courtesy of the Scarab Club Archives.)

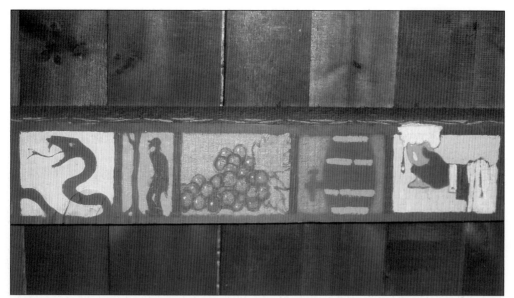

Walter Spouse painted the Wet Spell beam, a symbol of the beverages available prior to the 1920s Prohibition. Pictured are a bunch of grapes representing wine, a keg of beer, and a frothing cup of brew so enjoyed by Scarab members since the first informal meeting. Even though Prohibition was in full force, Scarabs still found a way to imbibe. (Courtesy of the Scarab Club Archives.)

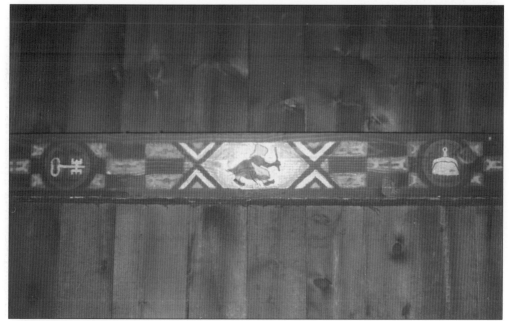

John Jewell exemplified the house committee by illustrating a Dutch cleanser girl, key, dustpan, pad lock, and whisk broom. A member once wrote, "This beam is very attractive in its simplicity of green and yellow and its symbols of industry and guardianship, but one is apt to suspect that golden brooms and dust-pans may lack somewhat of usefulness." (Courtesy of the Scarab Club Archives.)

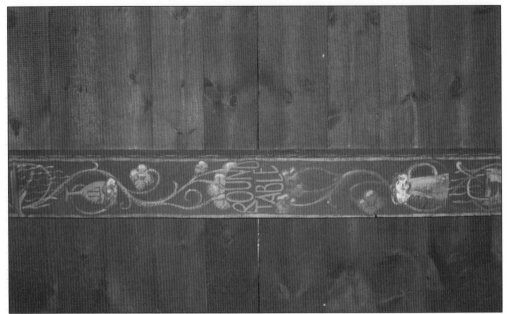

Max Colter decorated the Round Table beam. In the December 1928 issue of the *Scarab*, Shu Chai stated, "Round Table groups are usually composed of representatives of different arts, each displaying his own idiosyncrasies. . .. 'All fruit salad; no meat' says the artist, but [Colter] remembered the substantial part of the meetings with a . . . foaming stein and goblet." (Courtesy of the Scarab Club Archives.)

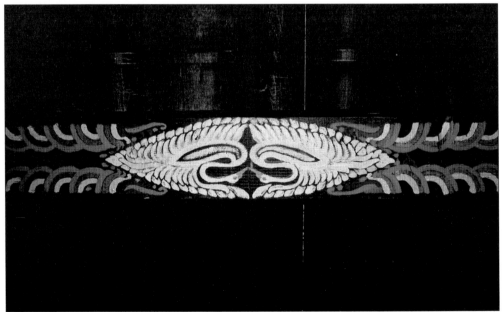

Ben March executed the Founders beam, the inspiration of Clyde Burroughs according to Shu Chai in the December 1930 *Scarab*. The center of the beam immortalizes the first president, James Swann. Chai states, "When Mr. Swann saw the beam, he declared that the whole decoration was in consonance with his own long and deep interest in Chinese philosophy and art." (Courtesy of the Scarab Club Archives.)

Mariam S. Aston (1916–2005) was one of the first Charter Women members of the Scarab Club elected to membership on December 11, 1962. Aston is pictured signing the beams in this George R. Booth Jr. photograph in the late 1980s. Aston, best known as a painter and sculptor, won the 1964 Scarab Gold Medal Award and was recognized as one of Michigan's top 10 artists. (Courtesy of the Scarab Club Archives.)

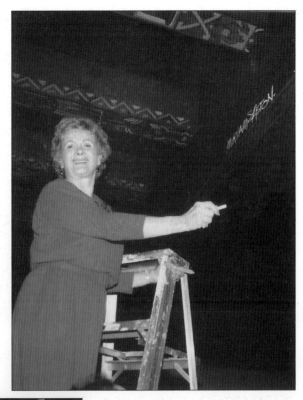

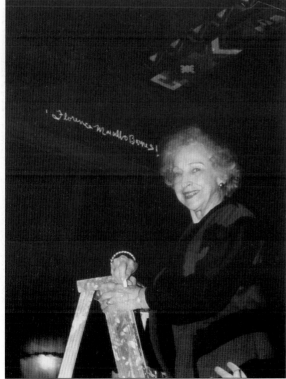

Florence Maiullo Barnes (1909–2006) was welcomed by William A. Bostick, past president, "It is with great pleasure that I am able to tell you [that] you were elected a Charter Woman Member of the Scarab Club of Detroit at the meeting of the Board of Directors held on December 11, 1962." Her beam signing was captured by George R. Booth Jr. in the late 1980s. (Courtesy of the Scarab Club Archives.)

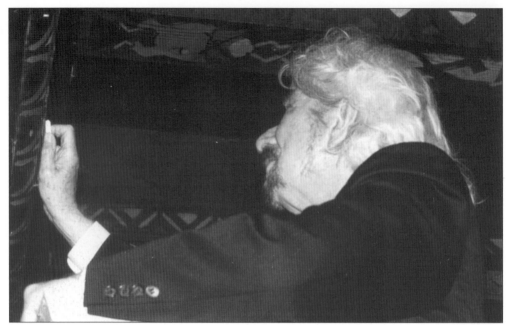

Pablo Davis (born in 1917) signed the beams next to Diego Rivera's signature, with whom he worked on the DIA Detroit Industry murals, during an exhibition of his work in April 2001. A political activist, accomplished artist, and teacher, Davis, depicted in the Patricia Reed photograph, is held in high regard and is most deserving of being immortalized on the "guest book." (Courtesy of the Scarab Club Archives.)

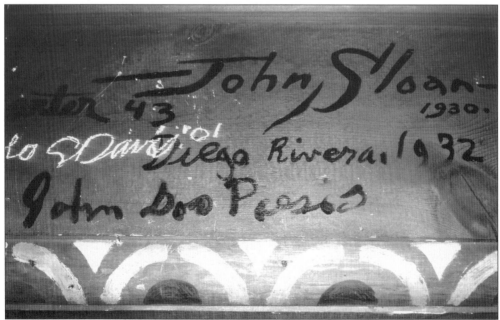

Note the s of *Davis* is signed over the *D* for *Diego Rivera*. Pablo Davis, who was 83 at the time, had a difficult time seeing the beams in the dimly lit room. However, it subtly represents his connection to Rivera. Additional artists' names inscribed on the beam include John Sloan, Ash Can School, and John Dos Passos, a novelist and artist. (Courtesy of the Scarab Club Archives.)

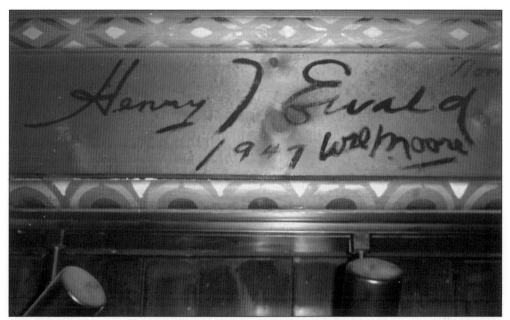

Besides his position as president of the Cambell-Ewald Company, Henry T. Ewald (born in 1885) helped the club regain its financial footing. After the board decided to refinance the mortgage in 1941 by selling 120 bonds, the club's financial condition improved. By 1947 all bonds except a total of $1,400 owned by Ewald were retired. He donated his share to the club, earning his place on the beams. (Courtesy of the Scarab Club Archives.)

Ewald applied for membership to the Scarab Club on March 21, 1935. His acceptance led to the generous bond donation. At the time, he lived in Indian Village, an upscale section of Detroit. Ewald's advertising business was located in the 13th floor of the Albert Kahn–designed General Motors building. An illustrator, Russ Legge, was one of his application sponsors. (Courtesy of the Scarab Club Archives.)

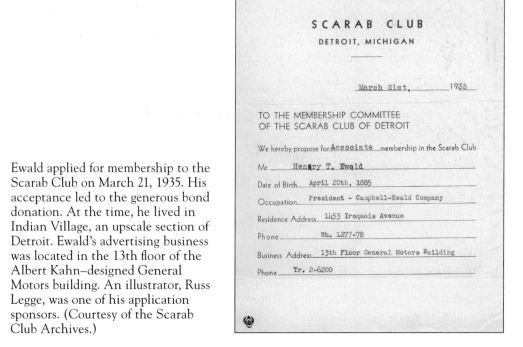

SCARAB CLUB

DETROIT, MICHIGAN

March 21st, 1935

TO THE MEMBERSHIP COMMITTEE
OF THE SCARAB CLUB OF DETROIT

We hereby propose for Associate membership in the Scarab Club

Mr. Henary T. Ewald

Date of Birth April 20th, 1885

Occupation President - Campbell-Ewald Company

Residence Address 1453 Iroquois Avenue

Phone Wh. 1277-78

Business Address 13th Floor General Motors Building

Phone Tr. 2-6200

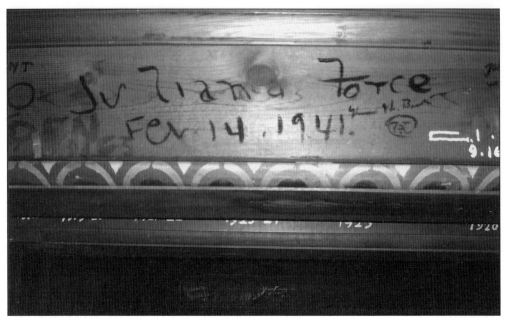

Juliana Force (1876–1948) holds a special place in club history as the first female to sign the beam, in 1947. As the first director of New York's Whitney Museum, Force is credited with establishing a stellar reputation for the American art museum. Although the men's-only club did not generally allow women onto the second-floor lounge, Force was an exception to the rule. (Courtesy of the Scarab Club Archives.)

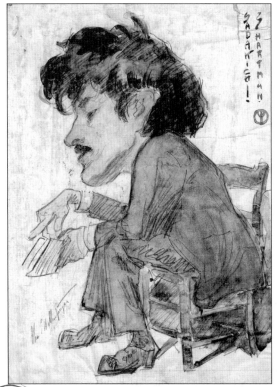

Sadakichi Hartmann (1867–1944), was invited around 1930 to sign the Scarab Club beams. As a prominent art critic and a regular lecturer at the club, Hartmann provided artistic stimulation for the membership and was an honored guest from the early years of the club's existence. Hartmann is immortalized in this 1914 *Scarab* magazine rendition by member Charles E. Waltensperger. (Courtesy of the Scarab Club Archives.)

Roman Gibbs briefly served as the mayor of Detroit from 1970 to 1973. During his three-year term, Gibbs supported the efforts of the privately funded Detroit Renaissance, Inc., which was instrumental in the construction of the Detroit Renaissance Center, the largest privately financed project in the world. (Courtesy of the Scarab Club Archives.)

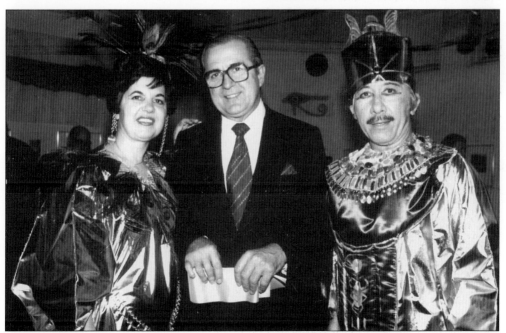

Detroit mayor Roman Gibbs poses with club president Alex Marinos and his wife at an early 1970s Beaux Arts Ball. Although not pictured in costume as the majority of guests were, Mayor Gibbs was allowed to join the festivities as a notable guest of honor. Gibbs's signature on the historic beams also proved his status. (Courtesy of the Scarab Club Archives.)

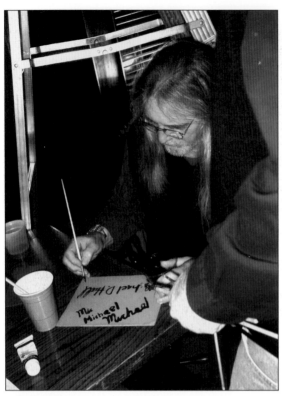

Michael Hall (born in 1941) is a prominent sculptor who retired as the head of the Sculpture Department at Cranbrook Academy of Art. His work is represented in numerous private and public collections. Hall, a folk art and American Midwest regional art expert, is pictured practicing his signature with the paints he used to inscribe his name on the beam in January 2004. (Courtesy of Patricia Reed.)

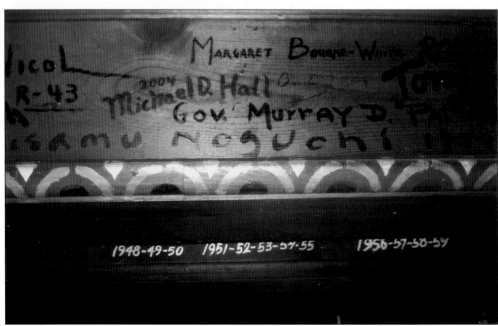

Michael Hall's signature graces the beam just below that of Margaret Bourke-White (1904–1971). Bourke-White was a renowned photographer who vividly captured the Midwestern towns of America during the height of the Great Depression, and worked as a photojournalist for *Time* and *Life* magazines. (Courtesy of the Scarab Club Archives.)

Although well recognized in the local and national art community, contemporary artist Charles McGee stood out among the crowd with his top hat during his September 2005 signing. McGee also elected to sign the beam with white paint rather than the customary black. Pictured are, from left to right, Pres. Patricia Reed, gallery coordinator Treena Ericson, Charles McGee, and in front is executive director Christine Renner. (Courtesy of Matt Renner.)

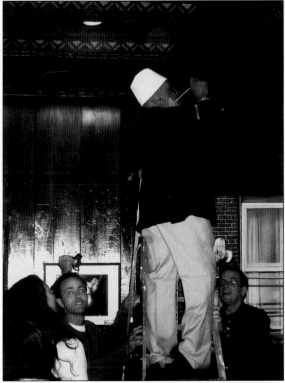

Charles McGee (born in 1924) has exhibited his paintings, assemblages, and sculptures in national and international collections. McGee's work is on permanent exhibition at the DIA and the Charles H. Wright Museum of African American History. In addition, McGee's work appears on the walls of the Downtown People Mover stations as well as at Troy Beaumont and Detroit Receiving Hospitals. (Courtesy of Matt Renner.)

William Murcko (born in 1946) is pictured here in a family photograph signing the beam in December 2001 at the ceremony following the Boars Head and Gold Medal Award dinner. He signed twice that evening. The first signature graced the president's beam, since Murcko was the club's president from 2000 to 2002. The second signature was afforded him as an artist and patron. (Courtesy of William Murcko.)

Former Michigan governor William Milliken (born in 1922) is pictured in this oil portrait by Scarab member Patricia Hill Burnett. Milliken served as governor from 1969 to 1982, which still is considered the longest length of service in state history. Nicknamed the "gentleman governor," Milliken was a passionate environmentalist who, along with his wife, supported legislature for the bottle return law. (Courtesy of Patricia Hill Burnett.)

Internationally renowned sculpture, designer, and landscape architect Isamu Noguchi (1904–1988) is pictured signing the Scarab "guestbook" in 1975. Next to him are Pres. James Taliana and member Edna Branch, who served as president from 1978 to 1979. Noguchi "believed that through sculpture and architecture, one could better understand the struggle with nature." Noguchi designed Detroit's Hart Plaza in 1975. (Courtesy of the Scarab Club Archives.)

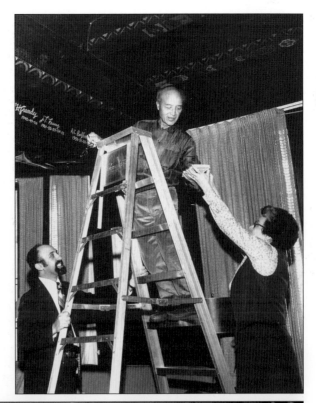

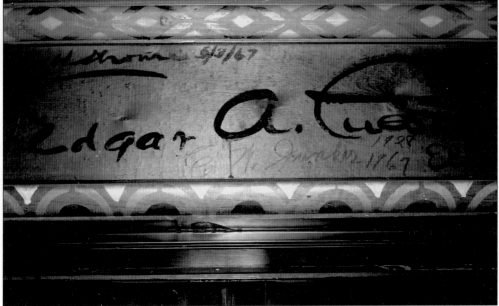

Affectionately nicknamed "the poet of the people," Edgar Guest (1881–1959) achieved national fame during the early 20th century for his poetry. Through his poem-a-day columns in the *Detroit Free Press* and NBC radio broadcasts, Guest reached a larger audience with his sentimental view of everyday family life. In 1952, Guest became Michigan's first and only poet laureate. (Courtesy of the Scarab Club Archives.)

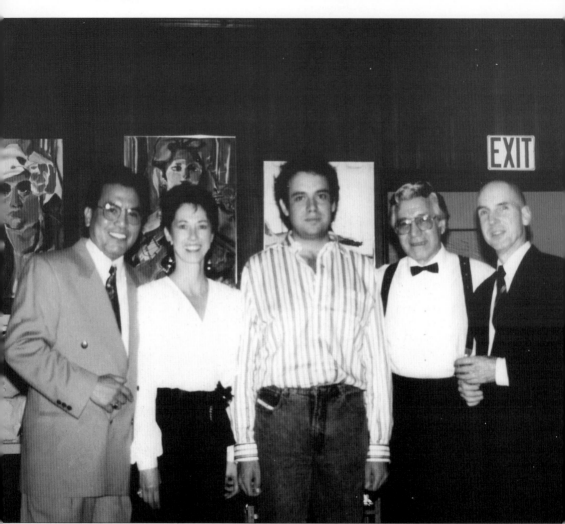

Juan Coronel Rivera, art curator, historian, and grandson of Diego Rivera, was invited to sign the beams during his visit to Detroit on October 31, 1991. His signature is below that of his grandfather's. Pictured are, from left to right, Jose Romero, Rachael Harla, Juan Coronel Rivera, Al Gutierrez, and Charles Kelly, Scarab president. Rivera's signature, dated 1991, appears on page 75 in white chalk below signatures of Detroit mayor Roman Gibbs and writer Max Eastman. (Courtesy of the Scarab Club Archives.)

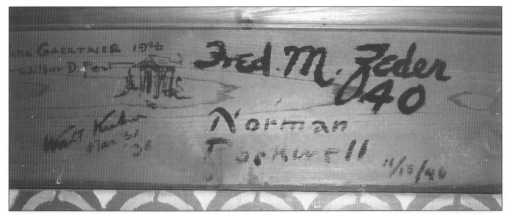

Norman Rockwell (1894–1978) was featured in a 1947 *Detroit Times* article that stated the "painter of the 'Four Freedoms' add[ed] his name to those of illustrious artists on the beams of the Scarab Club." He is best known for his illustrated *Saturday Evening Post* covers and American genre illustrations. Frederick Simper, Scarab member, once gave an oral account of the beam signing event where he claimed that Mary Rockwell's fur was missing from the coat room after the dinner and signing. Members were extremely embarrassed by this. J. L. Hudson Company came to the rescue by donating a fur for the cause. Simper recalled that he and another member hopped into a car with the donation and drove to Massachusetts to deliver it with hopes of spending some time with Rockwell in his studio. The anticipation turned into disappointment when the gate guard would not let them in, even after explaining why they were there. He would not even let them leave the fur. Simper believed the coat was eventually shipped to Mrs. Rockwell. (Courtesy of the Scarab Club Archives.)

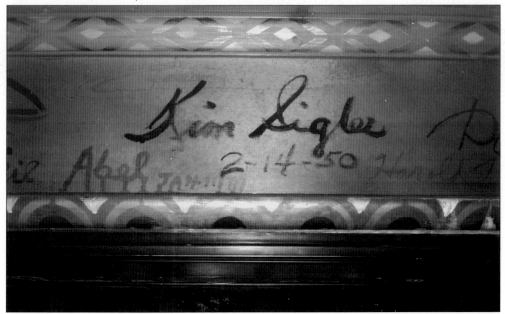

Kim Sigler (1894–1953) served as Michigan governor from 1947 to 1949. Although he was only in office for two years, Sigler is credited with creating the Department of Administration, revitalizing the unemployment compensation program and the Public Services Commission, and making positive changes in the Prison and Corrections Department. Note that Sigler signed the beam in 1950, one year after leaving office. (Courtesy of the Scarab Club Archives.)

Maryann Mahaffey (1915–2006), Detroit city councilwoman since 1974 and city council president from 1990 to 1998 and 2002 to 2005, was known for her feisty personality, always standing up for what she believed was the right stance the city should take on outstanding issues. Pictured here is Mahaffey paying tribute to legend John Sinclair at his beam signing. Sinclair stands behind the ladder. (Courtesy of Patricia Reed.)

John Sinclair (born in 1941) is pictured with Ellen Hildreth, Scarab poet in residence, in this photograph donated to the Scarab Club archives by her husband, Michael Madias. On November 4, 2004, Sinclair added his name to the beams, as a tribute to the Detroit Artist Workshop. Sinclair is best known as a musical and literary artist in addition to being a political activist. (Courtesy of the Scarab Club Archives.)

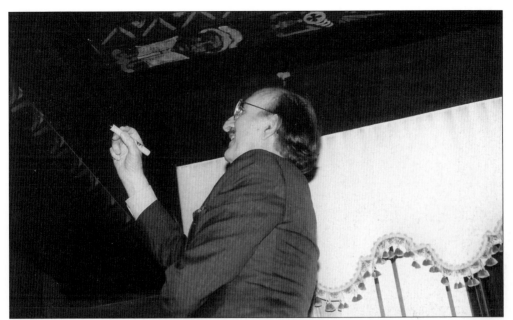

Tony Spina (1914–1995) was the chief photographer of the *Detroit Free Press* from 1952 to 1989. Spina's photojournalism captured Detroit's history, making the nation and world aware of the city's triumphs and hardships, including the 1967 riots. Spina is pictured signing the beam while at the 1990 signing of his book *Tony Spina – Chief Photographer, Four Decades of His News Photography from the Detroit Free Press*. (Courtesy of the Scarab Club Archives.)

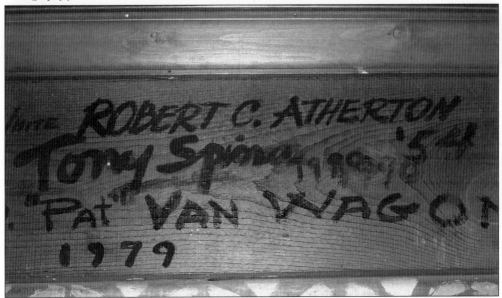

Murray D. Van Wagoner (1898–1986) served as governor of Michigan from 1941 to 1942. Prior to his election, Van Wagoner was the state highway commissioner from 1933 to 1940. Several of his accomplishments include the construction of the first highway roadside park and permanent information center. As governor, Van Wagoner responded to Pres. Franklin D. Roosevelt's request in making Detroit the "Arsenal of Democracy" during World War II. (Courtesy of the Scarab Club Archives.)

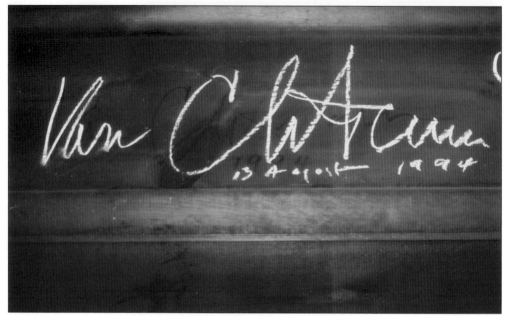

American pianist Van Cliburn (born in 1934) became world famous in 1958 after winning the first quadrennial International Tchaikovsky Piano Competition in Moscow during the Cold War at the young age of 23. During the late 1980s, Van Cliburn performed at the White House for Pres. Ronald Reagan and Soviet Premier Gorbachev. Recently he was awarded the 2003 Presidential Medal of Freedom. (Courtesy of the Scarab Club Archives.)

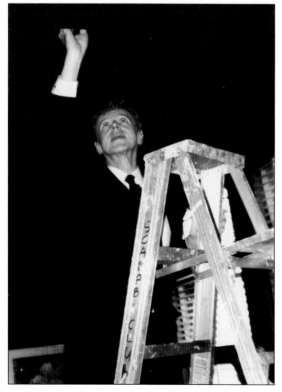

Pictured signing the beam in 1994, Van Cliburn, like all other Scarab beam signers, joined the lengthy list of honorary members of the club. Although nationally and internationally renowned for his performances for various royalty and heads of state, including all U.S. president's since Harry Truman, Van Cliburn was very modest in his fame. (Courtesy of the Scarab Club Archives.)

Six

COSTUMED BALLS
AND EVENTS

What do hardworking, serious Scarab artists do to relax? They have a ball of course! The first costume ball held in 1917 was themed Fashion in the Year 2017. It was open to members and guests by invitation only. Attendees were asked to ignore the traditional costumes such as cowboys, cops, and robbers, stay away from the costume rental shops, and encouraged to design their own from items they had handy. Prizes were awarded for the best costumes. Newspapers carried photographs of the outlandish attire.

The second ball held in 1920 was so successful that it continued annually until 1950. Sporadically, it was resurrected in the 1970s and 1990s. Since 2002, Cirque, an annual masked ball, is the result of a partnership between the Scarab Club and the Founders Junior Council of the DIA.

In the early days, planning the event was a communal club activity. A chairperson was appointed, a theme agreed upon, and imaginations ran wild. Members decorated invitations, which were sent out to a list of who's who in Michigan. Artists rallied to paint murals and design and build lavish decorations. In the early days, the Women's Exchange was hired to provide the supper, professional entertainment was employed, and tickets were a mere $6.50 per couple.

By 1937, the balls were so popular that *Life* magazine came to the Scarabean Cruise to cover the event with an essay and photograph spread depicting guests in an array of costumes from the Caribbean exotic to undersea diver's–style gear.

Other events were planned as well, such as feather parties, Christmas dinners (now called the Boars Head Dinner), garden parties, and holiday gatherings, among others. In the earlier years, these events provided a fruitful environment for member artists, patrons, and guests to potentially network in addition to merrymaking. Scarabs were known to celebrate in bohemian style from their inception as the Hopkin Club. The spirit continues in the tradition handed down from Scarabs past.

The first ball theme was the Scarab Ball of 2017 and was captured by photographer Frank Scott Clark. The first invitation was rather crude in appearance and read, "If you had a son and he had a great grandson and a great granddaughter, they would surely be garbed in their day as you and your mate will be—Sat. Evening, February 10, 8 o'clock, Scarab Club, Addison Hotel." (Courtesy of the Scarab Club Archives.)

Much thought was given to what future generations would be wearing in the next 100 years. Not much seemed to change as far as fashion in 2017 according to the costumes worn by guests Edith and Clyde Burroughs at the ball held at the Addison Hotel, current quarters for the Scarab clubhouse, photographed by Frank Scott Clark. (Courtesy of the Scarab Club Archives.)

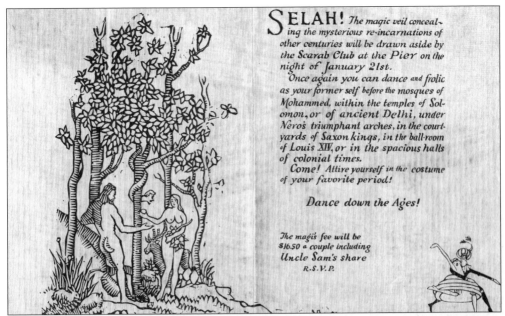

SELAH! *The magic veil conceal-ing the mysterious re-incarnations of other centuries will be drawn aside by the Scarab Club at the Pier on the night of January 21st.*

Once again you can dance and frolic as your former self before the mosques of Mohammed, within the temples of Solomon, or of ancient Delhi, under Nero's triumphant arches, in the courtyards of Saxon kings, in the ball-room of Louis XIV, or in the spacious halls of colonial times.

Come! Attire yourself in the costume of your favorite period!

Dance down the Ages!

The magi's fee will be $16.50 a couple including Uncle Sam's share R.S.V.P.

The 1921 invitation, "Dancing Down the Ages with the Scarab Club, Historical Ball Masque," enticed Scarabs to attend the third ball. According to the November 15, 1920, board of director's meeting minutes, estimated expenses totaled $3,300 with predicted ticket revenue generated by special $55 box tickets, $16.50 tickets per couple, and $10 per member. Decorations were lost in a fire at the Pier. (Courtesy of the Scarab Club Archives.)

In this 1922 ball photograph, Clyde Burroughs proudly models his costume for photographer Frank Scott Clark. Dressed as a romantic sultan from early Arabia, he looks ready to charm a harem of ladies. However, his wife, Edith, was most likely his partner of choice at the Twenty Centuries of Romance ball. (Courtesy of the Scarab Club Archives.)

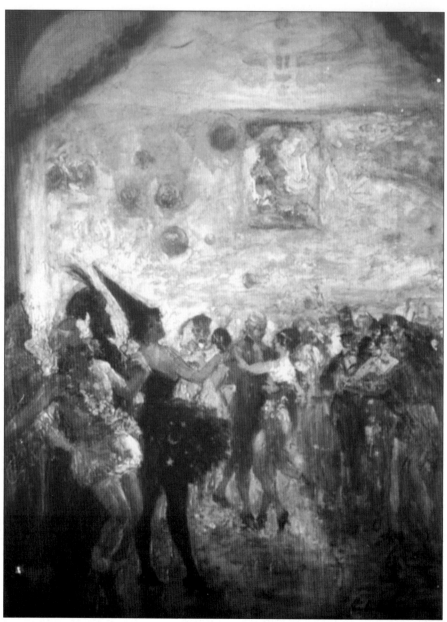

Charles Waltensperger painted this scene titled *Beaux Arts Ball* of the 1922 ball. The year of this painting was determined by coming across a 1922 newspaper article with sketches of ball costumes, which appear in this painting. The floating balloons were a novelty and provided free of charge by the Pier. Note the winged scarab in the upper center section of the painting. Competition was fierce between costume companies to provide costumes for the balls. According to the club's correspondence with the costumer Lester Ltd. of Chicago, "two plans occurred to us, however, one of which is to send the Club a number of costumes and have them rent them for whatever they care to. The other plan is to make up a series of sketches and anyone wishing to order them can have their measurements taken and send them in to us and we will make the costume up to order to rent or rent it from our stock." (Courtesy of the Randell and Patricia Reed.)

Don Kennedy is pictured as "Temperance" in this 1922 photograph by Frank Scott Clark. This Scarab mocked Prohibition in the 1920s. Scarabs were not exactly temperate or teetotalers. At one board meeting during Prohibition, a letter was read from the Wayne County Sheriff's Department warning the club that someone notified them that alcohol was being served there. (Courtesy of the Scarab Club Archives.)

Prior to the mailing of invitations, each member was requested to provide a guest list. Invitations for the 1928 Under the Big Top ball were designed by Scarab artists and sent by club manager Ernest Junker to members and their guests. Although invitations were limited to 500 couples and were restricted to guests on previous ball lists, keeping the number limit was difficult. (Courtesy of the Scarab Club Archives.)

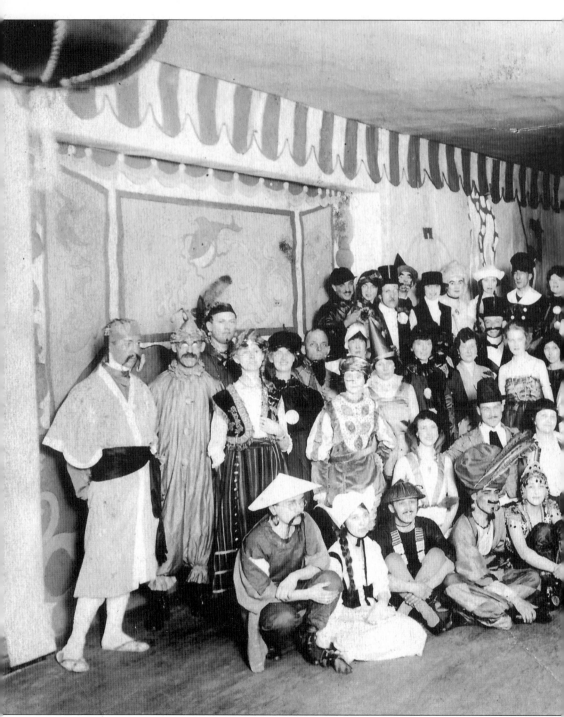

Guests were captured as a group in this 1928 photograph of the Under the Big Top ball. The party room was decorated with the circus theme at the Greystone. Early Scarab Club balls were held at different locations throughout the city of Detroit. Various locations included the Ponchatrain Hotel, the Addison Hotel, the Book Cadillac Hotel, the Pier, and the Greystone. The balls usually were scheduled in late January or early February with the start of the festivities

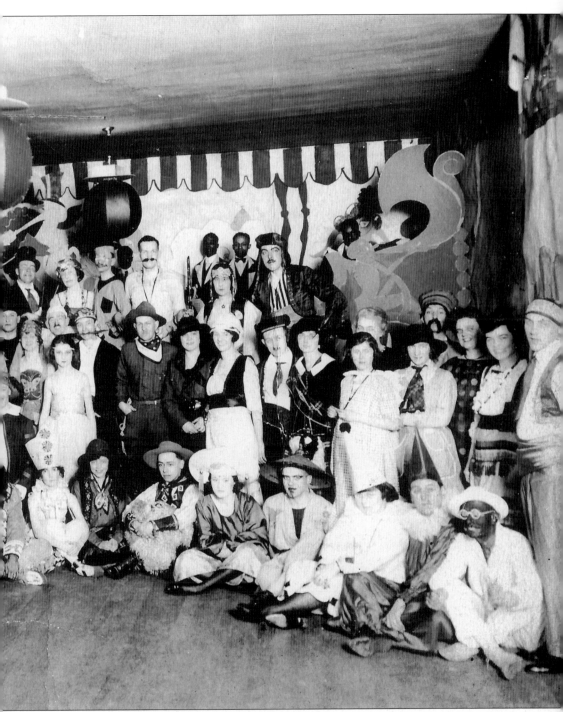

beginning as early as 9:00 p.m. and running until the early morning hours with a special midnight grand march. Breakfast was served to all remaining stragglers the next day. The Book Cadillac once quoted the price of $300 for their entire ballroom floor and breakfast for 600–1,000 guests at $1 or $1.25 per person. (Courtesy of the Scarab Club Archives.)

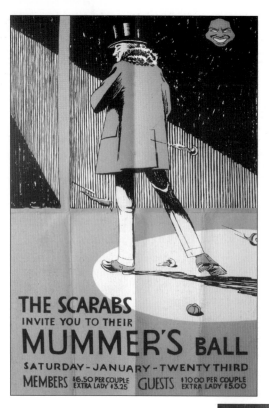

THE SCARABS
INVITE YOU TO THEIR
MUMMER'S BALL
SATURDAY - JANUARY - TWENTY THIRD
MEMBERS $6.50 PER COUPLE EXTRA LADY $3.25 GUESTS $10.00 PER COUPLE EXTRA LADY $5.00

Ball themes were decided by an appointed Scarab Club ball committee. Several interesting themes included Night in a Forbidden City (1920), Twelve Centuries of Romance (1922), A Scarabean Nocturne (1924), A Scarabesque Phantasy (1926), Under the Big Top (1928), Ball Bizarre (1930), Mummers Ball (1932), A Night on Olympus (1934), A Night with the Immortals (1936), and A Night Of Romance (1938). (Courtesy of the Scarab Club Archives.)

In a 1935 correspondence to the Society of Women Artists, the Scarab Club president wrote, "We believe that this event, so well known in the annals of Detroit's artistic life, has become a more comprehensive character We would, therefore, like to see your Club, which can contribute so much to such a social affair, represented at the forthcoming frolic." (Courtesy of the Scarab Club Archives.)

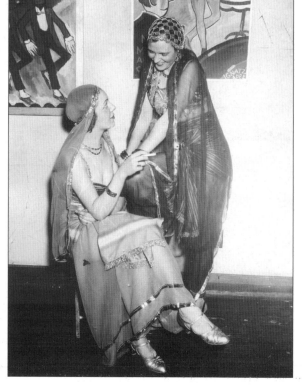

The house committee sent a notice along with invitations stating, "The House Committee has ruled that Members and Guests may not bring liquor in bottles or other containers into the clubhouse on the night of the Ball It will be quite apparent that the attending hazards to revelers bringing their own liquor, place too great a responsibility on the Club." (Courtesy of the Scarab Club Archives.)

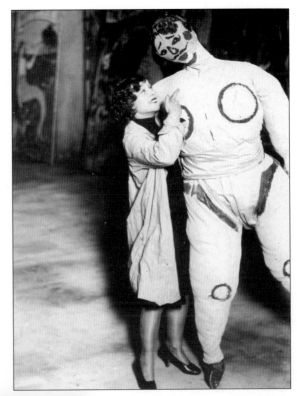

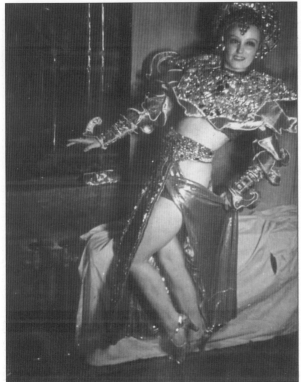

A 1938 *Detroit News* article states, "Guests at the Book Cadillac Hotel underwent some peculiar experiences . . . in the lobby and elevators, and if they didn't enjoy them it was because the guest looked at life with a jaundiced eye . . . the Scarab and their guests . . . portrayed romance as a thing capable of existing with very little covering even in a Detroit January." (Courtesy of the Scarab Club Archives.)

According to literature pertaining to the creation of ball murals, artists' sketches were first approved by the Scarab Club ball committee. After the approval process, a small lantern slide was made of the sketch, which was projected on a large canvas. The artists' sketches were outlined from the projected image. Once the outline was drawn, the panel was filled in. (Courtesy of Scarab Club Archives.)

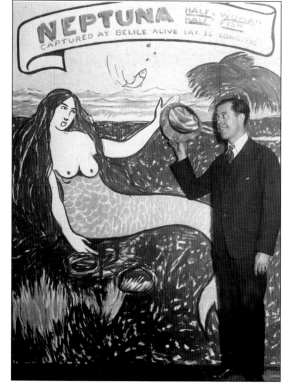

Controversial artist murals inspired an argument over censorship between the Book Cadillac Hotel and Scarab Art Committee. In a brief Scarab explanation of the controversy, the panels had "too little clothing" and were not allowed to be hung. Scarabs protested and asked for a committee to be appointed consisting of "society women, a well known judge, business man, or pastor." The panels were later approved. (Courtesy of the Scarab Archives.)

The ball guest lists included members from various clubs in the city, such as the University Club, University of Michigan Club, the Bohemians, Michigan Society of Architects, the Players Club, and the Adcraft Club. In addition, invitations were sent to art schools such as the Cranbrook Academy of Art, Society of Arts and Crafts, Detroit School of Art, Young Artists' Market, Detroit Academy of Art, Crafts Guild, George Rich Class, and the Meinsinger Foundation. Passes were also sent to the local newspapers, including the *Detroit Times, Detroit News, Detroit Free Press,* and *Motion Pictures.* The Scarab ball committee stated that no one could come without an invitation, sponsored by a member, or the Scarab ball committee. In addition, guests would not be admitted without costumes, and there would be none available at the ballroom. Guests dance to the music in this 1939 photograph by Norman H. Hammerl. (Courtesy of the Scarab Club Archives.)

Orchestras competed for the coveted entertainment position at the Scarab Club balls. Detroit entertainment companies such as Finzel Orchestras and Attractions, Inc.; Musical Artists Bureau; Paramount Attractions; Del-Ray Orchestras and Entertainment; Jules Klein Artists Bureau; Paul E. Field Radio; Stage and Ballroom Attractions; and the Dave Diamond Organization sent letters to the club promoting their upcoming bands. (Courtesy of the Scarab Archives.)

Guests were encouraged to dress in creative costumes, not the usual cowboys, witches, and pirates, for example. However, one guest dressed as an artist. Was he or was he not himself that evening? It is none other than Sidney Walton, a Scarab who was also a member of the American Watercolor Society. (Courtesy of the Scarab Archives.)

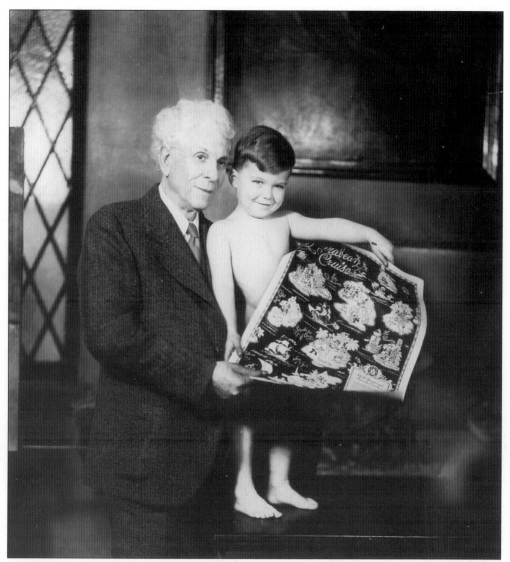

Frank Scott Clark was involved in all ball activities from 1917 to 1937, so it was fitting to feature him in this photograph by Lee Redman announcing the Scarabean Cruise. The club sent out the following press release, "The New Year baby, in the person of little Stewart Woodruff, brings an invitation to the Scarabean Cruise, the 1937 Ball, to Frank Scott Clark, well-known photographer, one of the founders of the Scarab Club and the most active member in the staging of the Club's earliest balls. The Ball will be held at the Book-Cadillac on January 29, 1937. 'Mr. Clark, you can go on the Scarabean Cruise dressed as a Fiji Islander, an Eskimo or an Egyptian,' said Stewart." Fortunately for the club, *Life* magazine covered the ball with a two-page spread of photographs showcasing guests in their imaginative costumes. (Courtesy of the Scarab Club Archives.)

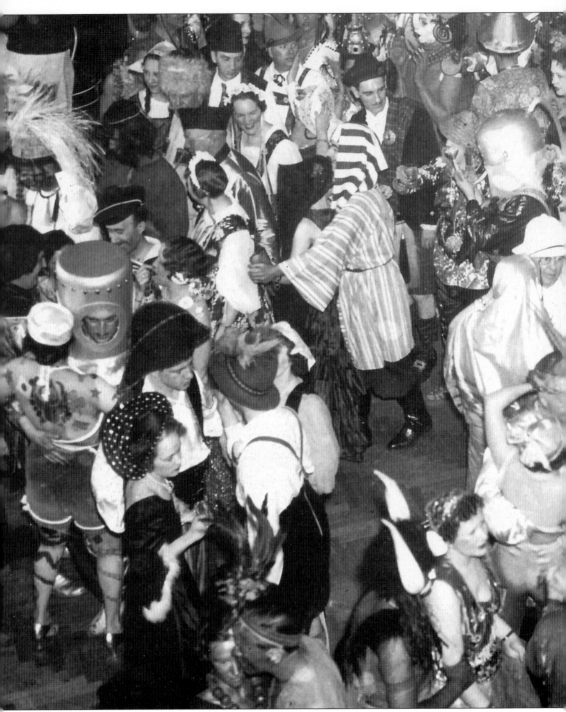

The Scarab Club balls were the social event of the season and were attended by some of the most prominent members of Detroit society. According to an unaddressed and unsigned letter on Scarab Club letterhead, "Two thousand invitations to the 1935 Scarab Ball were poured into the mail Friday to make this year's Ball at the Graystone on the night of Feb. 8th the most splendid affair the Detroit's artists club has ever produced. Among those invited, who are expected to

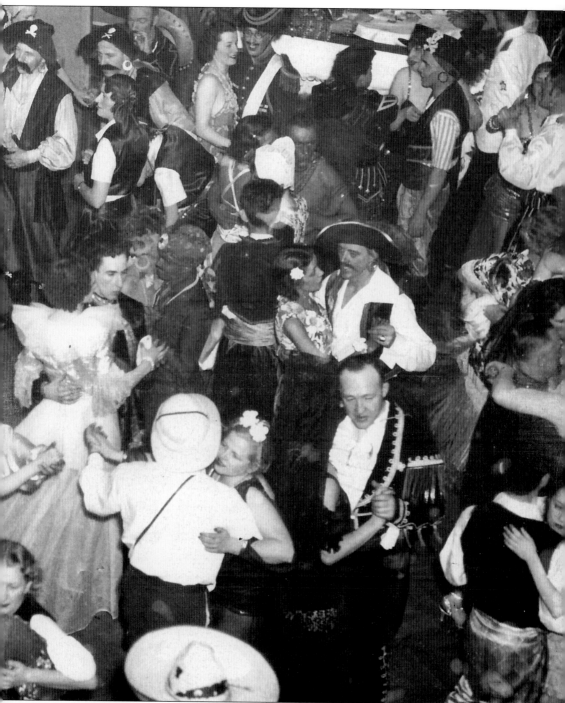

attend are the following: Mr. and Mrs. L. C. Hughes-Hallett of the British Consul, Mr. Corley Smith of the British Vice-Consel, Mr. and Mrs. Edsel Ford . . . Mr. Charles Fisher . . . Mrs. Ralph Booth, Mr. and Mrs. Albert Kahn, Mr. and Mrs. D.M. Ferry . . . Mr. and Mrs. Joseph Dodge." (Courtesy of the Scarab Club Archives.)

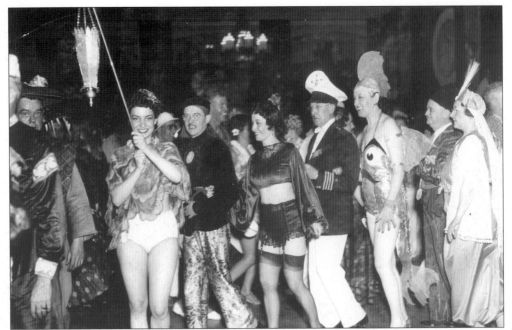

The grand march was a highlight of the evening usually taking place at midnight. Each year a celebrity was chosen to be the queen of the ball. Leading the march is a 15-year-old actress who was chaperoned by her mother so she could party with the Scarabs. (Courtesy of the Scarab Club Archives.)

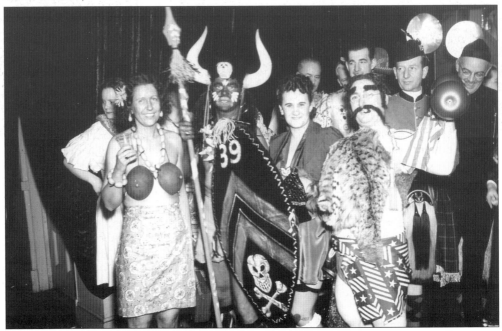

This 1939 Scarabal Renascence–themed ball featured some interesting costumes. One guest creatively indicated the year on the shield as a costume prop. After 20 balls, the guests finally got the idea that originally designed costumes gave the event a flavor of its own. (Courtesy of the Scarab Club Archives.)

Beaver Edwards is pictured on the left working on the 1949 ball, themed the Scarab Mardi Gras. It was held on February 25, 1949, at the Scarab Club. The invitation announced, "No gentleman without a lady. NO one admitted without costume. Attendance limited to 150 couples." Many members were involved at all levels of preparing for the balls. Even nonmembers and other organizations were recruited to help make this event memorable. Scarab Club balls were organized by the Scarab ball committee and various subcommittees consisting of invitations, decorations, police and censors, ballroom and breakfast, publicity, passes and favors, finance and expense, and office detail. The invitations committee was responsible for tickets, envelopes, pass tickets, invitations, instruction slips for guests, notice to members, box reservations, return envelopes, and all matters pertaining to invitations except stamps. (Courtesy of the Scarab Club Archives.)

The decorations committee took care of all decorations, lighting effects, and special wiring for photographers. The police and censors committee was responsible for inside and outside policing and providing special officers for dance floor censors, member censors, and a fireman as well as doormen. The ballroom and breakfast committee made all contracts with the facility including all details pertaining to the ball, such as music, attendants, lighting, check room, safety-deposit boxes, lost articles, coat room service, soft drink handling, ushers, box office equipment, and ticket boxes. The publicity committee took over all matters pertaining to publicity, and the passes and favors committee provided complimentary tickets, passes, and special favors (salaries and bonuses). The finance and expense committee approved expenses of every nature before any obligation was entered into by any subcommittee; and the office detail committee, which was a one-person committee of Ernest Junker, assisted the secretary and handled telephone calls, blue prints of box layouts, files, invitation lists, and all office details. (Courtesy of the Scarab Club Archives.)

102

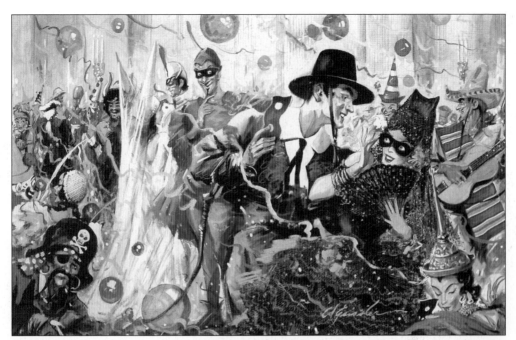

Scarab artists loved to portray their enjoyment of club activities by representing it in their art. Ed Geissler, a prominent advertising art illustrator, painted this rendition of a costumed ball around 1950. This piece was donated and is in the permanent collection of the Scarab Club. It truly is a prized treasure. (Courtesy of the Scarab Club Archives.)

The ball continued sporadically after 1950. Several balls were held during the 1970s, one celebrating the country's 200th anniversary. Several Beaux Arts balls were held in the 1990s. Cirque is the masquerade ball of the 21st century. Pictured is the 1970s ball titled Scarabean Nights. It depicts members and guests in appropriate costumes. (Courtesy of the Scarab Club Archives.)

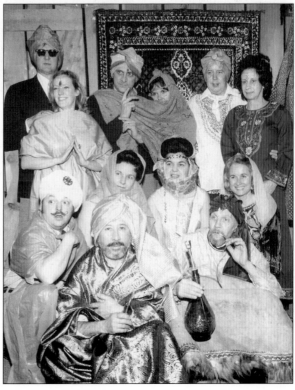

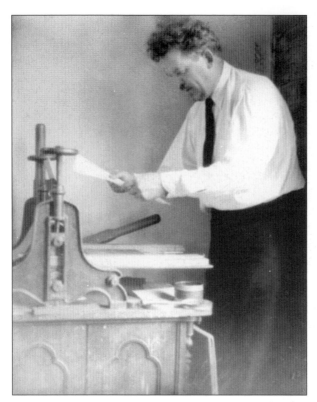

The ground floor provides space for many activities. Pictured in this George W. Styles photograph is Paul Honore possibly working on a party invitation or event notice during a lithography session. Instruction in printmaking, photography, and sketching were varied art activities that were scheduled in the basement on a regular basis in the early days. (Courtesy of the Scarab Club Archives.)

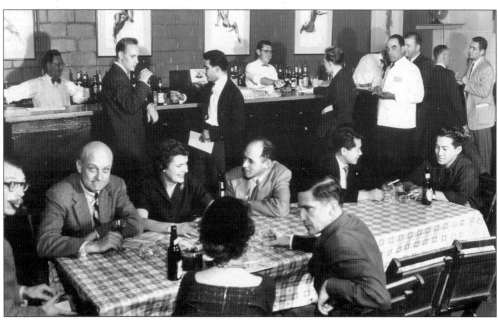

"The Tap Room is used for all special occasions. It has been the scene of gay Scarab gatherings—on Christmas, New Year's and St. Patrick's days as well as on the annual Scarab Ball. The walls of this attractive room are gaily decorated with sketches by club members." This 1953 photograph by Ransier Studio appeared in a club marketing brochure. (Courtesy of the Scarab Club Archives.)

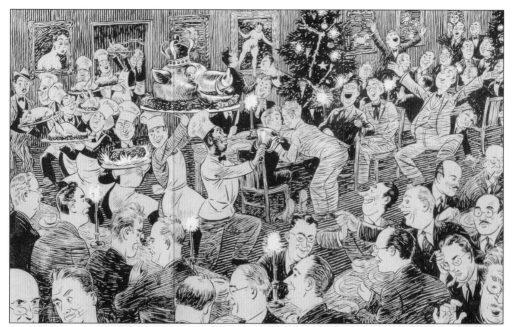

Al Apel's sketch features traditions of the late-1940s Henry VIII Dinner. The boar's head and other succulent meats were paraded around by new members, to the delight of the old, who are depicted in character. Subjects of art hung on the wall look eager to join in. The bell carried by the parade leader is still in use. (Courtesy of the Scarab Club Archives.)

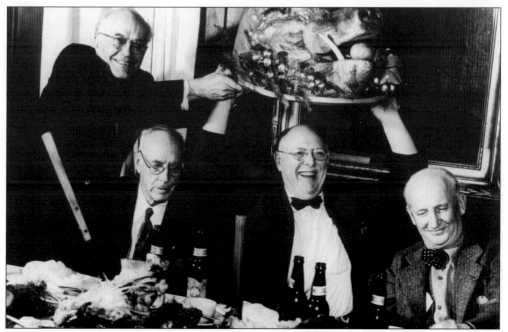

The annual Boars Head Christmas dinner received its name from the old tradition of parading around a boar's head at past Christmas dinners. Although the heads used in the old days were from real boars, the club uses a painted, fake replica boar's head today created by members several years ago. This photograph dates from the 1950s. (Courtesy of the Scarab Club Archives.)

Cirque is an annual masquerade ball partnered by the Scarab Club and the Founders Junior Council of the DIA since 2002. Pictured in full party enjoyment are, from left to right, Elizabeth Smith Lenhard, Mary Freund, Monica Lenhard, and Marisa Lenhard. In the tradition of the past Scarab Club balls, this fund-raiser event provides entertainment and a strolling supper. (Courtesy of Patricia Reed.)

Pablo Davis volunteered to donate sketched portraits at the Detroit Festival of the Arts. At 90 years old, he still takes portrait painting commissions and plays the Scarab Club Santa Claus during the University Cultural Center's Noel Night the first Saturday in December. Davis is a notable artist who worked on the Detroit Industry Rivera murals at the DIA in the early 1930s. (Courtesy of Patricia Reed.)

Seven

STUDIO TENANTS PAST AND PRESENT

Oh what tales could be told, of third-floor revelries new and old, of artists toiling for creation for their patrons' anticipation; what mystery beckons behind closed doors? Studios establish a special environment for artistic inspiration. Early Scarabs developed a communal work area from a partition at the first clubhouse on Gratiot Avenue, giving artists a space to work and for models to pose for sketch sessions. By 1922, the Forest Avenue clubhouse had an existing building in the rear that was later renovated to accommodate artist studios. Although a new clubhouse was built in 1928 with studio accommodations, the old location was still maintained and studios were rented until the property was sold.

The Scarab Club Bulletin, May 1927, reported on the proposed Farnsworth clubhouse stating, "The third floor (which is intended for future expansion of Club quarters) will therefore be divided into eight 'trial' studios. If they prove themselves self-supporting, popular, an easily-managed department and not a source of worry, trouble, and dept, the studio building will eventually be erected on the rear of the property and the third floor taken over for Club quarters." Preliminary plans were included in the article, and members were asked for comments and suggestions. Obviously the plans were modified; there are six studios on the third floor (favoring a front and back stairs and bathroom with shower) and one in the basement that was formerly the caretaker's apartment. Needless to say, the expansion was not realized and was a victim of the Great Depression.

The third-floor studios are configured in a loft manner to maximize usable space. Large vertical windows take advantage of natural light and, when open in the summer, aid with a cross breeze when opposing studio windows are open.

The current roster of studio holders is an eclectic group, all of who have the common bond of art. Two are working artists foraging a living on their talents, two are photographers with outside employment. The remaining few have achieved success in business, engineering, as a fine arts professor and artist, and as a museum curator.

Around 1926, Charles Barker (born in 1878) settled in Detroit, taught art locally, was the Detroit Crafts Guild founder, and was a Scarab Club member. Barker demonstrates the printmaking process in this George W. Styles photograph, from a collection of *c.* 1930 photographs by Styles. Barker won the Etching Prize at the Michigan Artists Exhibition in 1929 for *Bones and I.* A copy of the etching is in the club's permanent collection. (Courtesy of the Scarab Club Archives.)

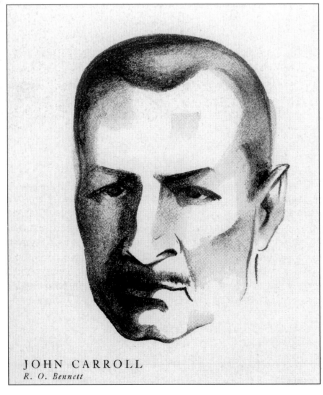

JOHN CARROLL
R. O. Bennett

John Carroll (1892–1959), characterized by Floyd S. Nixon in the December 1930 *Scarab*, came to Detroit to teach at the Art School of the Detroit Society of Arts and Crafts, had a Scarab Club studio, signed the beams, and was the club president in 1940. Carroll completed a commission of three lunettes, which are installed in the DIA American wing. (Courtesy of the Scarab Club Archives.)

Patricia Hill Burnett (born in 1920), in this *c.* 1965 Scarab Club studio photograph featured in her book *True Colors*, fondly recalls as the first female tenant that "five male artists would have to contend with the sheer horror of a woman painter working among them . . . there was one . . . restroom for the entire floor . . . it turned out that the Scarabs . . . maintained an open door policy. Modesty led me to ask about . . . a lock for the door." She made cocktails available, and the male tenants warmed up because shortly thereafter she went "into the washroom to find, on the other side of the door— a tiny gold lock." Burnett, Miss Michigan 1942 and founder of the Michigan Chapter of the National Organization for Women and at least 12 additional chapters around the world, is a sculptor and prominent portrait artist who has captured images of notables around the world such as Marlo Thomas (actress), Barbara Walters (newscaster), Margaret Thatcher (prime minister), Gloria Steinem (feminist and author), and Rosa Parks (civil rights leader). (Courtesy of Patricia Hill Burnett.)

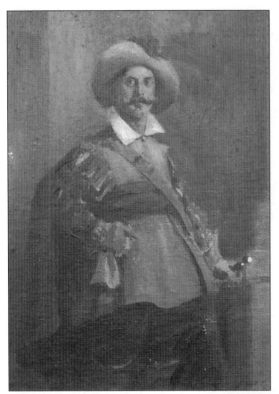

Joseph W. Gies, founding member of the Scarab Club, painted this self-portrait of a Swashbuckler. It is quite possible it was just a costume selected for the moment, or it could have been a costume he designed or rented for one of the many Scarab costumed balls. Steven Boichet, grandnephew of Gies, donated this painting to the Scarab Club. (Courtesy of the Scarab Club Archives.)

Joseph W. Gies (1860–1935), one of the first studio tenants at the East Forest Avenue clubhouse, is best known as a portrait and landscape painter. Gies studied at the Cooper Union, National Academy of Design, Art Students League, and in Paris and Germany. Gies is pictured in a studio photograph donated to the Scarab Club by his grandnephew, Steven Boichet. (Courtesy of the Scarab Club Archives.)

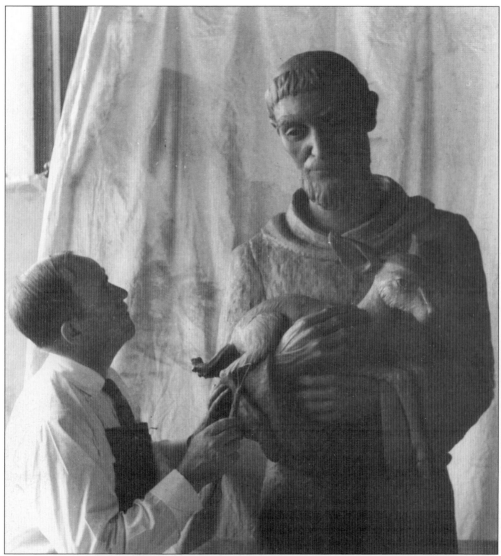

Charles Beaver Edwards (1899–1986), occupied studio six during his tenancy. Edwards studied at the Detroit School of Fine Arts and Art Institute of Chicago, and taught at Wayne State University's College of Mortuary Science and University of Michigan's College of Architecture. He was elected in 1950 as a Fellow of the Royal Society of Arts, London. As a member of the Scarab Club, Edwards won the Gold Medal Award in 1938 and served as president in 1939. "Beaver," as he was fondly called, was a sculptor who exhibited regularly at the Annual Exhibition of Michigan Artists from 1928 to 1955. Pictured from his collection of undated photographs donated to the Scarab Club, Edwards stands next to his clay model for Saint Francis, Bloomfield Hills, Michigan. Beaver is best known for his prosthesis modeling of soldiers suffering from disfiguring injuries from World War II. (Courtesy of the Scarab Club Archives.)

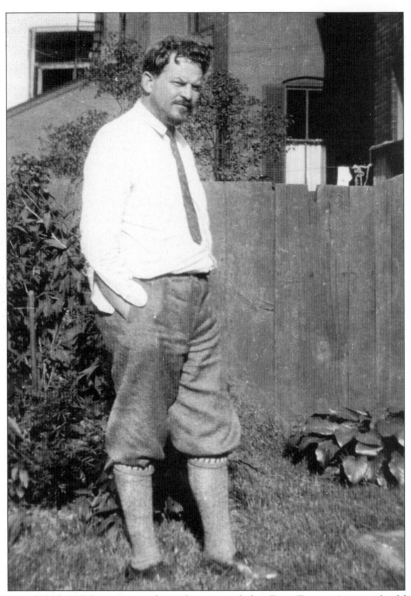

Paul Honore (1885–1956) is pictured in the rear of the East Forest Avenue building. The February 1925 *Scarab* mentions, "The [East Forest Avenue] studios are ready for occupancy, and anyone wishing to get in touch with Joseph Gies, Paul Honore, R. O. Bennett, and Sid Walton will find them installed in their new quarters at the rear of the Clubhouse." Honore was one of the first Farnsworth studio tenants. Known as a painter, printmaker, and renowned muralist, Honore's murals decorate the Midland County Courthouse, Dearborn Public Library, First State Bank in Detroit, People's Church in Lansing, National Research Council in Washington, D.C., Michigan Building, Century of Progress Exposition, and Dearborn High School. Ken Randall mentions of the Midland Courthouse murals in the April 23, 2006, *Midland Daily News*, "The historical murals . . . are made out of . . . 'plastic mosaic.'" Randall indicates that Honore worked with Bloodgood Tuttle, a Cleveland architect and Scarab, and the Dow Chemical Company to produce this material made from local brine, consisting of chloride, magnesia cement, and colored ground glass. (Courtesy of the Scarab Club Archives.)

112

Paul Honore, captured in this 1930 George W. Styles photograph, is recognized in the February 1925 *Scarab*, "The friendly spirit of competition of the decorations was accentuated by a prize of $100, which was awarded to Paul Honore, amidst the plaudits and congratulations of his fellow workers. On the strength of the prize money Paul seems to have added to the dignity of his personal appearance with a haircut." (Courtesy of Scarab Club Archives.)

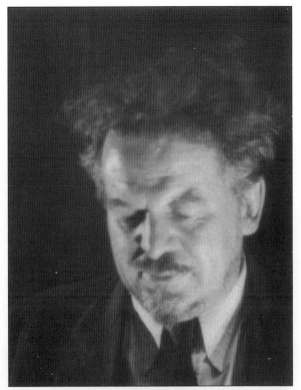

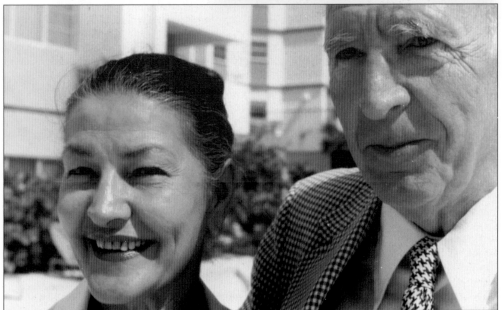

John Coppin (1904–1986) and wife Sidni are pictured in this 1970s photograph. His 1929 membership application indicates that he was a portrait illustrator and art director of *Detroit Motor News Magazine*. In 1940, 1944, and 1946, Coppin won the Gold Medal Award and served in 1946–1947 as president. In 1983, the National Portrait Gallery purchased a Coppin portrait of Sadakichi Hartmann for $7,000. (Courtesy of the Scarab Club Archives.)

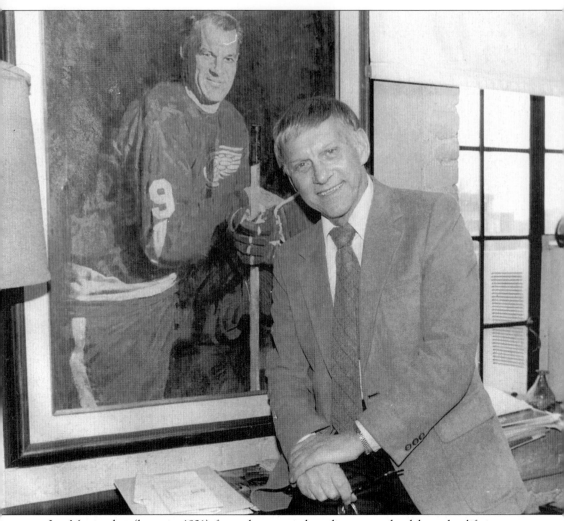

Joe Maniscalco (born in 1921) formerly occupied studio one and celebrated a lifetime career as a portrait painter. He studied at the Art Students League in New York. Maniscalco is a past president of the Scarab Club, serving in 1972–1973 and 1987–1988, and a four-time Scarab Club Gold Medal Award winner in 1970, 1976, 1985, and 1997. According to the Maniscalco Gallery of Fine Art Web site, during his younger years, Maniscalco painted movie star portraits for Twentieth Century Fox Studios posters and was a freelance artist for prominent art studios. Some of his renowned portrait commissions portray chief justices of the Michigan Supreme Court, United States senators, and congressmen such as John Dingell. His portraits of Congressmen William Ford of Michigan, Augustus Hawkins of California, and William Clay of Missouri hang in the Capitol Building in Washington, D.C. Even famous Detroit Red Wings hockey players Gordie Howe and Steve Yzerman called upon Maniscalco to render their images. Maniscalco is pictured with his portrait of famed Red Wing Gordie Howe. (Courtesy of the Scarab Club Archives.)

George Rich and John Tabb (1923–2001) were both studio tenants in the late 1940s through the 1950s. Rich is pictured in Tabb's studio in this 1953 Ransier Studio photograph. Rich taught at the Art Institute of Chicago and the Meinzinger School of Art in Detroit. He was a Scarab Club Gold Medal Award winner in 1930 and 1949. Although Tabb's paintings are shown hanging on the studio walls, it bothered him a little that the photographer had arrived while he was away and photographed his good friend Rich in his place. Tabb taught at the Meinzinger Art School, Marygrove College, and retired from his art director position at General Motors. A four-time winner of the Gold Medal Award in 1952, 1954, and 1956 and amazingly again 38 years later in 1994, Tabb proved he never lost his artistic touch. He served as president in 1996–1997. (Courtesy of the Scarab Club Archives.)

Sidney Walton (1876–1940) was one of the first artists to rent a studio at the East Forest Avenue clubhouse in 1925 and new Farnsworth building in 1928. When Walton signed the lounge beams, he also wrote "AWS" after his name indicating he was a member of the American Watercolor Society, a great honor. Walton studied under Scarabs Joseph W. Gies and Francis Petrus Paulus. He is pictured in a third-floor studio, possibly Honore's or his about 1930 in this George W. Styles photograph. Pictured are, from left to right, Frank Packman, Paul Honore, Sidney Walton, and Floyd Nixon. Walton and Honore were among the first tenants at the 217 Farnsworth clubhouse along with Reginald Bennett, Roger Davis, Conrad Lubnau, and A. H. Pomeroy. Roger Davis rented from July to September 1928, after which Roger B. Davis became the tenant in October 1928. Studio artists often invited others into their studios for art discussions and other activities. (Courtesy of the Scarab Club Archives.)

Studio tenants fondly call themselves "the Noise Upstairs" and posed for this photo by VATO for a collaborative exhibition postcard. Pictured from bottom to top, left to right, are VATO, studio two; Jeanne Bieri, studio three; Joseph M. Neuman, studio six; Randell Reed, studio one; SLAW, studio two; James W. Tottis, studio five; and William Murcko , studio four. James W. Tottis is the club's current president, a writer, and associate curator of American art at the DIA. VATO, a talented photographer and writer, explains, "My work in eros visually shows the power within ourselves to express that discovery in its purest and raw form." Studio artists work individually and also collectively to share ideas about their art. The privately rented studios are not open to the public. However, on special occasions such as exhibition receptions, club fund-raisers, Detroit Festival of the Arts, and Noel Night, most are willing to open them to the community so patrons can view and purchase their work and catch a glimpse of how studios are utilized. (Courtesy of VATO.)

Kelly Lockwood (née Hornfeld), ground-floor studio tenant and graduate of Michigan State University with a bachelor of arts with a major in photography, states, "I am driven to capture honest moments that go unnoticed—a quick glance or gesture that reveals what it's like beneath the surface of chaotic, everyday life." She is pictured here at her June wedding in a Patricia Reed photograph. (Courtesy of the Scarab Club Archives.)

William Murcko, studio four, is a portrait painter who is the 2001 Gold Medal Award winner, Scarab past president from 2000 to 2002, and artist beam signatory. Murcko claims to be "primarily self-taught." He honed his skills studying at the Realist Art School in France, Florence Academy of Art in Italy, and New York Academy of Figurative Art in New York. (Courtesy of William Murcko.)

SLAW, studio two, commented in a recent *News-Herald* quote, "Life is to be enjoyed and laughed at. You can make fun of yourself and laugh at others if it's in a good nature. I try to present that aspect in my art." SLAW, an illustrative 1950s and 1960s painter, is pictured in his studio during the 2004 Detroit Festival of the Arts. (Courtesy of the Patricia Reed.)

Joseph M. Neumann, studio six, is a still life and realist painter featured in this promotional photograph taken by his wife, Lisa. Neumann states, "By painting in the Trompe L'Oeil genre of illusionistic realism, I attempt to capture Americana, and express the opposition between high culture and popular culture." Recently Neumann was featured in a Trompe L'Oeil exhibit at the Michigan State University Kresge Art Museum. (Courtesy of Lisa Neumann.)

Jeanne Bieri, pictured peering out of her studio window at the 2006 Detroit Festival of the Arts, is an accomplished painter and assemblage artist who "sees herself as a scientist, constantly experimenting with patterns and relationships and distilling core realities that entice viewers to recognize both haphazard and intentional relationships." (Courtesy of George R. Booth Jr.)

Randell Reed, studio one, is a painter influenced by early-20th-century modernists. Reed states, "Over too many years I have had the God given opportunity to be creative in one fashion or another. This process has allowed me not only to use my mind but also my hands which are important facets in the creative outcome. The work becomes whole when appreciated by others." (Courtesy of Patricia Reed.)

Eight

21ST-CENTURY SCARAB

What will be revered by future generations as the Scarab Club's significance in the 21st century and its role in shaping the city of Detroit's artistic and cultural soul? Following its original mission to "educate and enlighten its members and the community in the arts," the 501(c)(3) nonprofit Scarab Club's significance in the 21st century is to continue to provide education and enlightenment to the public through classes, workshops, sketch sessions, rotating artist exhibitions in its main and lounge galleries, and by the sponsorship of various artistic endeavors at the clubhouse (such as the Chamber Music Concert Series, now in its ninth season), the Detroit Blues Society Blues Concert Heritage Series, Springfed Arts Writers Workshop, and Detroit Docs (an independent documentary film organization). In addition, the club strives to shape the future of the arts in metro Detroit by leading the "Detroit Artist's Project," a joint venture with Detroit artist gallery owners/directors to form a strong community of artists and arts leaders.

Perhaps the most challenging goal for the 21st century is the maintenance of the clubhouse. The 78-year-old architectural gem is in desperate need of renovation. Older, outdated electrical and energy systems make the building vulnerable to unforeseen circumstances. Currently the club is seeking funding to rehabilitate the historic clubhouse to ensure another 100 years of artistic education and enlightenment.

On the cusp of its centennial in 2007, plans are underway to celebrate the organization's heritage. Throughout 2007, the Scarab Club plans to host various fund-raisers open to the public, such as the revived Scarab Club Costume Ball in March, a birthday celebration in May, and a garden party in June. Historic memorabilia and timelines will be on display depicting club history.

As always, the Scarab Club invites the public to visit its galleries, attend its programs and events, view its historic architecture, and meet working artists in their studios while encouraging artists to enter work into juried exhibitions and participate in weekly sketch sessions. The club proudly opens its doors to the 21st century and beyond while looking forward to the promotion of and participation in all future artistic endeavors.

The Scarab Club's Chamber Music Series reflects the vision of Nadine Deleury and Velda Kelly, founders and co-artist directors. Since 1998 it has developed a strong and loyal following by featuring local and international artists who perform an outstanding calendar of concerts. This photograph from July 2006 shows, from left to right, Kelly and Deleury performing at Fête de la Musique. (Courtesy of George R. Booth Jr.)

In 2003, the Scarab Club partnered with the Arts League of Michigan through a Michigan Council for Arts and Cultural Affairs and National Endowment for the Arts grant for three exhibitions and four events. All that Jazz was an event that introduced the community to several jazz performances. Marian Hayden and orchestra were captured by Patricia Reed in this June 2003 photograph. (Courtesy of the Scarab Club Archives.)

Photographer George R. Booth Jr. portrays member Jim Riopelle sketching a model in this recent photograph. Sketch sessions were instituted at the club's inception and remain an active, artistic, educational program at the Scarab Club. When the clubhouse was built in 1928, the ground floor was designated as an area for sketch sessions and other art classes. (Courtesy of the Scarab Club Archives.)

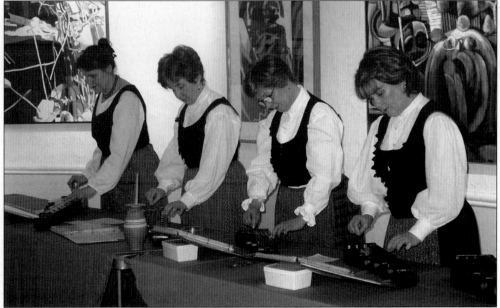

Many recent open houses and membership drives, popular with the community, have been organized by George Booth, who scheduled sketch session demonstrations, arranged for the opening of the private third-floor studios, asked members to donate snack food, and scheduled entertainment. Pictured in this Patricia Reed photograph is the Hungarian Zither group. On the far left is Reka Zoltan, Scarab Club member. (Courtesy of the Scarab Club Archives.)

The Boars Head and Gold Medal Award event is one of the year's highlights. This December holiday dinner has been continuously celebrated since the organization's beginning. Pictured here, in a Patricia Reed photograph, is Michael Goler, who was welcomed to membership in a 21st-century tradition. New members are introduced to existing members by asking them to sign their apron following a wine offering. (Courtesy of the Scarab Club Archives.)

Bringing members and friends together is what makes a fraternal organization pleasurable. Socializing in this Lynn Jovick photograph are members, from left to right, Lisa Neumann, Jerry Iwankowski, Del Iwankowski, Patricia Reed, George Booth, and Christine Mikesell at the recent Mardis Gras–themed Valentine's Day party held in the Scarab Club lounge. (Courtesy of the Scarab Club Archives.)

Members are encouraged to volunteer on committees to help plan events and other club activities. Pictured in this 2003 photograph by Patricia Reed is Lynn Jovick, the social committee chairperson, at the June Scarab Club garden party. This annual themed event celebrates the garden committee's efforts to beautify and maintain the courtyard garden with food, entertainment, and camaraderie, which makes it a memorable one. (Courtesy of the Scarab Club Archives.)

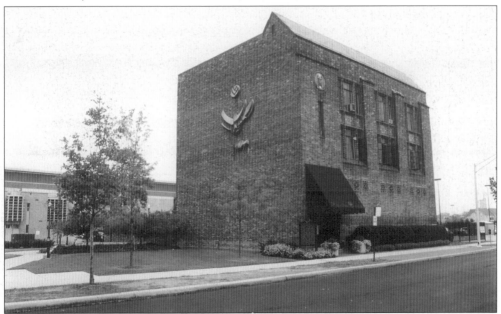

The Scarab clubhouse as it appears currently is pictured in this George R. Booth Jr. photograph. In 2000, J. L. Hudson Company donated funds to construct and landscape an art park adjacent to the Scarab Club and for the installation of the Scarab Club State of Michigan Historic Marker. In the centennial year, a capital campaign for clubhouse rehabilitation will be the major focus. (Courtesy of the Scarab Club Archives.)

PAST PRESIDENTS

James Swan	1912–1913	James A. Taliana	1974–1975
Joseph W. Gies	1913–1918	Fred Moorehouse	1975–1976
Frank Scott Clark	1919–1920,	George B. Howell	1976–1978
	1923–1924	Edna Branch	1978–1979
Arthur Marschner	1921–1922	Alex Marinos	1979–1981
Henry G. Stevens	1925	Pat Bramley	1981–1982
Clyde Burroughs	1926	Gil Treweek	1982–1983
Willie G. Sesser	1927	Larry B. Fink	1984–1986
Stanley Lewis	1928	Madeline Long Kerr	1987–1988
John A. Morse	1929–1930	Charles Kelley	1989–1990
Joseph Kraemer	1931–1935	Thomas W. Brunk	1990–1991
Russell Legge	1936–1937	Al Gutierrez	1992–1996
Al Apel	1938	John B. Tabb	1996–1997
Beaver Edwards	1939	Clara Dixon	1998–2000
John Carroll	1940	William Murcko	2000–2002
Horace S. Boutell	1941–1945	Patricia Reed	2002–2006
John S. Coppin	1946–1947	James W. Tottis	2006–2008
Hal H. Grandy	1948–1950,		
	1965–1966		
Joseph T. Franz	1951–1955		
Robert C. Barfknecht	1956–1959		
Otto Simunich	1960–1961		
William A. Bostick	1962–1963		
Russell Ingham	1963–1964,		
	1969–1970		
Arthur A. Parquette	1967–1968		
Michael Church	1968–1969		
George R. Booth Jr.	1970–1972,		
	1988–1989,		
	1997–1998		
Joe Maniscalco	1972–1973,		
	1987–1988		
Bernice Carmichael	1973–1974		

BIBILIOGRAPHY

Andrews, Wayne. *Architecture in Michigan*, Revised and Enlarged Edition. Detroit, MI: Wayne State University Press, 1982.

Barrie, Dennis. *Artists in Michigan 1900-1976*. Detroit, MI: Wayne State University Press, in association with the Archives of American Art, Smithsonian Institution, and the Founders Society Detroit Institute of Arts, 1989.

Colby, Joy Hakanson. *Art and a City*. Detroit MI: Wayne State University Press, 1956.

Crane, Michael, *Detroit's Annual Exhibition of American Art: The Foundation of a Collection with Accompanying Index 1915 to 1931, 1937, 1938*. Detroit Institute of Arts, 2005. www.dia.org.

Crane, Michael and Patricia Reed. *Index and Essay for the Annual Exhibition of Michigan Artists 1911 to 1973*. Detroit, MI: Manuscript, 2005.

Dunbar, Willis F. *Michigan: A History of the Wolverine State*. Grand Rapids, MI: Wm. B. Eerdmans Publishing Company, 1965.

Ferry, W. Hawkins. *The Buildings of Detroit A History, Revised*. Detroit, MI: Wayne State University Press, 1980.

———. *The Legacy of Albert Kahn*. Detroit, MI: The Detroit Institute of Arts, 1970 and Wayne State University Press, 1987.

Gibson, Arthur Hopkin. *Artists of Early Michigan*. Detroit, MI: Wayne State University Press, 1975.

Mason, Philip P. and Rankin, Paul T. *Prismatic of Detroit*. Detroit, MI: Prismatic Club, 1970.

Moore, Julia Gatlin. *History of the Detroit Society of Women Painters and Sculptors*. River Rouge, MI: Victory Printing Co., 1953.

Pear, Lillian Myers. *The Pewabic Pottery*. Des Moines, IA: Wallace-Homestead Book Co., 1976

Scarab Club. *The Bulletin*. Detroit, MI: The Scarab Club 1922–1932

Scarab Club. *The Scarab*. Detroit, MI: The Scarab Club 1913–1917

ACROSS AMERICA, PEOPLE ARE DISCOVERING SOMETHING WONDERFUL. THEIR HERITAGE.

Arcadia Publishing is the leading local history publisher in the United States. With more than 3,000 titles in print and hundreds of new titles released every year, Arcadia has extensive specialized experience chronicling the history of communities and celebrating America's hidden stories, bringing to life the people, places, and events from the past. To discover the history of other communities across the nation, please visit:

www.arcadiapublishing.com

Customized search tools allow you to find regional history books about the town where you grew up, the cities where your friends and family live, the town where your parents met, or even that retirement spot you've been dreaming about.